HEROIC DREAMS

TEXT

NIGEL SUCKLING

Paper Tiger

A Dragon's World Ltd Imprint

Dragon's World Ltd
Limpsfield
Surrey RH8 0DY
Great Britain

Produced by Martyn Dean

Hardback: ISBN 1 85028 035 5

Typeset by Florencetype Ltd, Kewstoke, Avon

Printed in Singapore

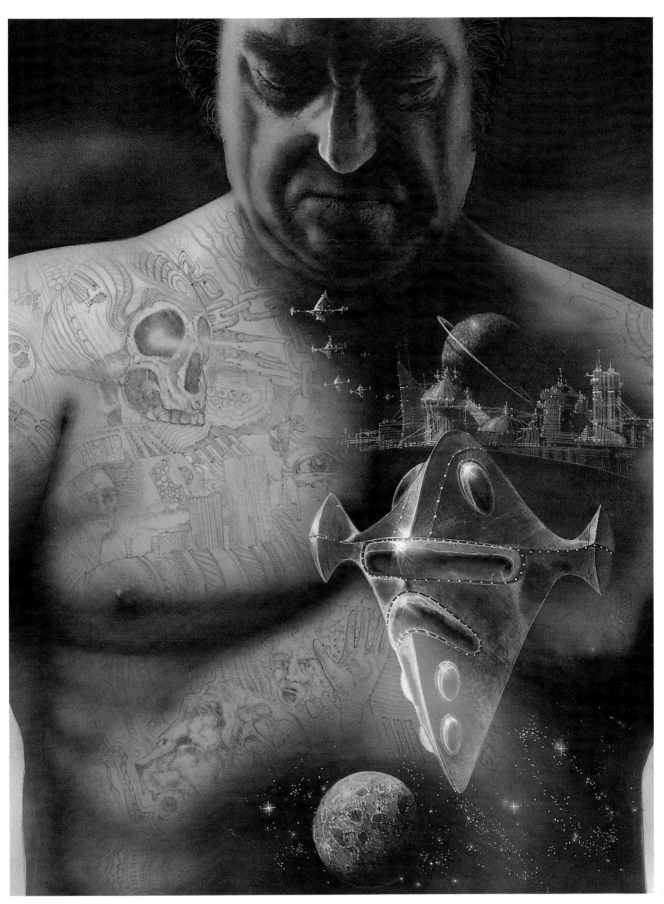

The Illustrated Man, Tony Roberts.

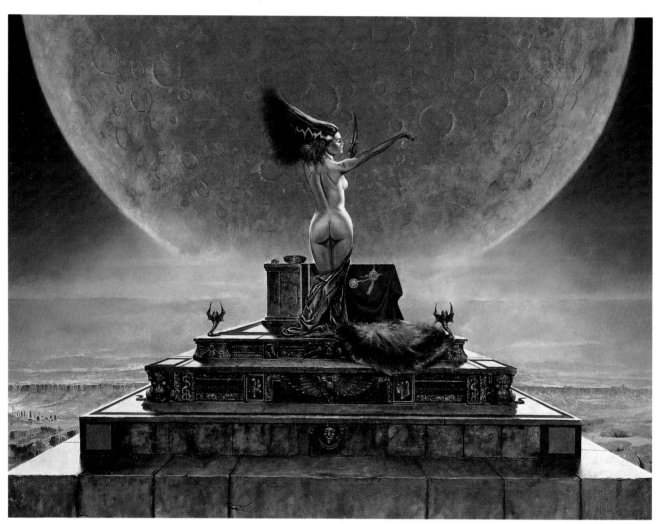

Aztec, Les Edwards.

CONTENTS

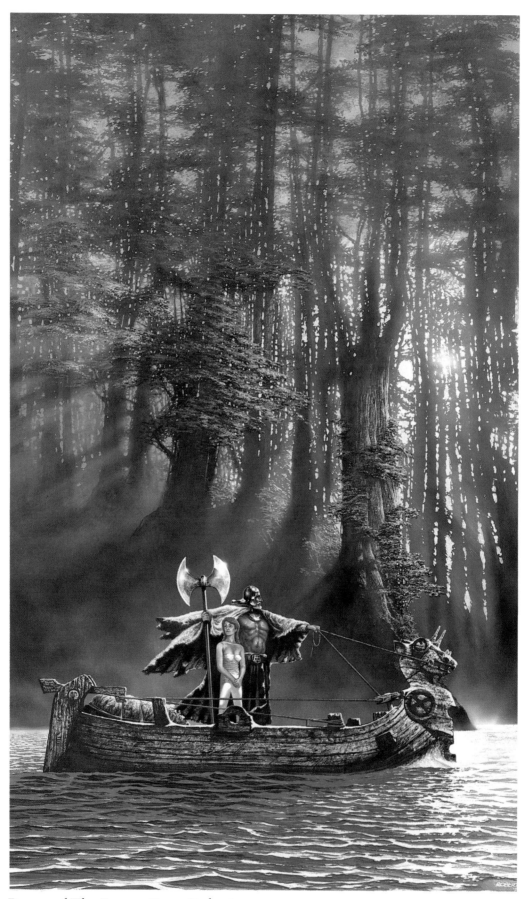

Dome of The Forest, Tony Roberts.

HEROIC DREAMS
INTRODUCTION

One can tell as much about a person by their heroes as by the company they keep, though naturally in both cases a degree of caution is needed to avoid jumping to the wrong conclusion.

Heroes and heroines personify what we would at least partly like to be, from the extent of being life models to simply being the objects of wishful thinking. They also tend to fall into quite definite categories although this is often disguised by the circumstances in which they appear. There is less difference than meets the eye between Conan the Barbarian and a Heavy Metal rock hero. Both take on and conquer a hostile world on their own terms, only their weapons differ.

Such hidden parallels explain the continuing fascination of heroes and heroines in fantastic settings, be they mythological, neo-mythological or futuristic. On any commuter train or car factory floor you will find Conans, Lancelots and Elrics, Galahads and Gueneveres disguised in the uniform of some modern profession and operating within (or not, as the case may be) limits defined by the prosaic present.

Barbaric heroes of the Conan type are common in early literature — Beowulf, for example, who in one of the earliest English poems takes on and kills Grendel, a semi-human monster who has been ravaging the hall of Hrothgar in Denmark. Then for his pains he has to face the wrath of Grendel's mother who lives at the bottom of a lake and, much later, a dragon provoked by the theft of some treasure it guards.

Other European examples which are perhaps better known are Hercules, Ulysses and Siegfried, who have equivalents in every other

culture. What these heroes have in common is that they live on the edge of Chaos where humanity (or that portion they identify with) is at the mercy of monstrous incarnations of evil and constantly threatened with extinction. Survival is the essence of their time and everything else a luxury. On the edge of Chaos humanity's nightmares are made flesh and would possess the world were it not for the Barbaric hero's might.

Early Celtic heroes of this kind live on in Irish and Welsh literature where their exploits were set down with surprisingly little censorship by the early Christian scribes. Their successors were the Arthurian heroes who, living in a somewhat less precarious age, embody a rather different heroic ideal. Now the necessary heroic qualities of might and courage are tempered by the ideals of Chivalry—with varying degrees of success. Certain heroes like Gawain give the impression that they would have been happier living in less reflective days.

In the Arthurian Age of myth (as opposed to the historical one) the forces of evil appear less often as monsters and giants, though these are still in evidence. More often they come in human guise. Humanity's enemies are now within and the crises faced by the central characters are quite often moral dilemmas. The heroic standards which applied to the earlier age are no longer sufficient and what the Arthurian cycle enacts is the universal human attempt to come to grips with its own success.

The young King Arthur was himself the epitome of the new Chivalric ideal but he later became a rather weak and ineffectual figure and was displaced by Lancelot, 'the best knight of the world'. Lancelot was acclaimed as this not only because he could thrash everyone in sight but because he also never transgressed the rules of Chivalry (except perhaps with regard to Guenevere). If he had possessed one quality without the other he would have slipped into a different role.

The Medieval concept of Chivalry meant much more than the protective attitude of men towards women with which it is largely associated now (and for which it is often attacked as being a disguised form of oppression). That was only part of the wider obligation which heroes were made to feel towards all who were weaker than themselves. Chivalry meant, and means in all the other contexts where it

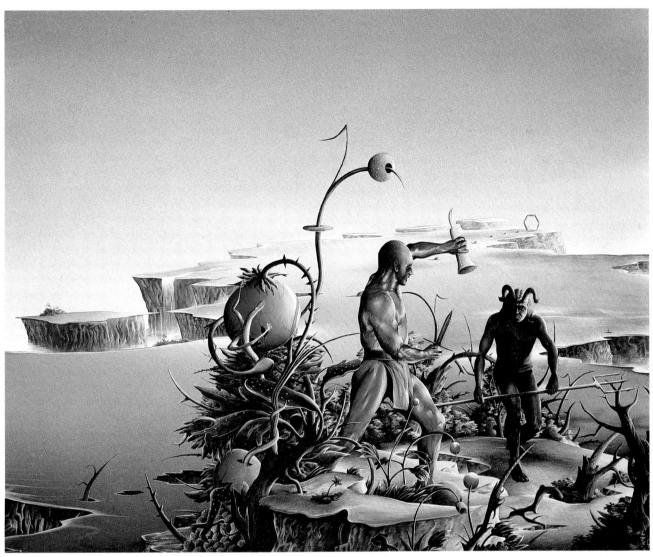

Makers of The Universe, Peter Goodfellow.

surfaces, the beginning of the subordination of might to an abstract code of justice which takes into account the rights of all members of society. It represents a distinct advance on the Barbaric code under which a hero's obligations are largely confined to the circle of his peers and chosen masters, and the poor and weak have little say in their own fate.

Towards the end of the Arthurian cycle the heroic ideal advances a further stage with the appearance of the Holy Grail. The Chivalric ideal is itself displaced by a new spiritual and wholly selfless one — the Mystical Quest — a doomed venture for most of the Round Table knights since they had found the earlier standard hard enough to meet.

The new heroic ideal is embodied in Galahad, Lancelot's son begotten while under an enchantment. Galahad takes the mantle of 'the best knight of the world' from his father and is the only one destined to fully achieve the Grail Quest because he is the only knight without

sin (by Medieval Romantic standards anyway, to our eyes the path he carves to the Grail may seem rather bloody).

Unlike most of the other Arthurian characters, Galahad is not easy to identify with simply because of his perfection. He has to be admired from afar. He appears to suffer none of Lancelot's torments of conscience and resists the advances of his many temptresses almost offhandedly. From the outset his sights seem set on a target beyond his immediate surroundings and he is tantalisingly elusive to those who wish to befriend him, always disappearing like the Lone Ranger when he has done his good deed.

These examples far from cover the complete range of hero-types but are widely enough spaced across the spectrum to show usefully the development of the ideal in ancient and modern myth. They appear in varying levels of disguise in all modern forms of art and literature (as shown by James Joyce's parody of the *Odyssey* in his *Ulysses*) but are perhaps most easily recognised in Fantasy and Science Fiction where storytellers have much the same imaginative freedom as the ancient legend-weavers.

Although presented here as a development of the Heroic Dream, this is not necessarily to say that one kind of hero is better than another. Each is appropriate to a particular age or condition and inappropriate to others. To go questing for the Grail while the rest of humanity is being gobbled up by dragons may not be heroic at all but merely escapist. Conversely, hunting dragons when they have become an endangered species and are no threat to anyone would be simply brutal.

In this book we have aimed to show how the stages of the heroic ideal in ancient myths and legends are mirrored in modern ones, as portrayed by a selection of Fantasy and Science Fiction illustrators currently working in Britain. This is not to imply that all the modern tales they illustrate are of the same calibre as the ones which gradually evolved over centuries or even millennia. Some are, some not. As with any artistic genre the quality ranges from the sublime to the ridiculous, from the works of serious writers like Arthur C. Clarke and Doris Lessing to—well, perhaps it is better not to say. The quality of the

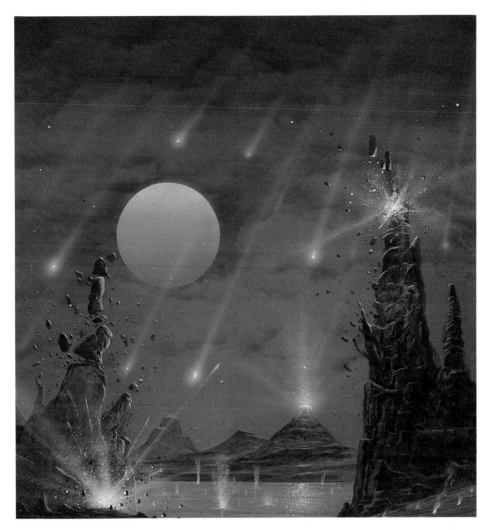

Book of The Damned, Angus McKie.

illustrations, however, is frequently much higher than that of the books they refer to.

But before we embark, it may be worth commenting very briefly on the phenomenon that, in both the modern myths and the older ones to which we will be referring, heroines are heavily outweighed by heroes.

With the ancient tales it is tempting to assume that they faithfully reflect the balance of power between the sexes in those times, but the absence of many real heroines may well be due to the same reasons they are rare in Fantasy and Science Fiction—that the stories were largely composed by men and so mainly reflect masculine dreams, fantasies and preoccupations.

Why there are not now more writers like Ursula le Guin and Anne McCaffrey to redress the balance is a bit of a mystery, but perhaps it is because women generally have come to look elsewhere for reflections of their imagination.

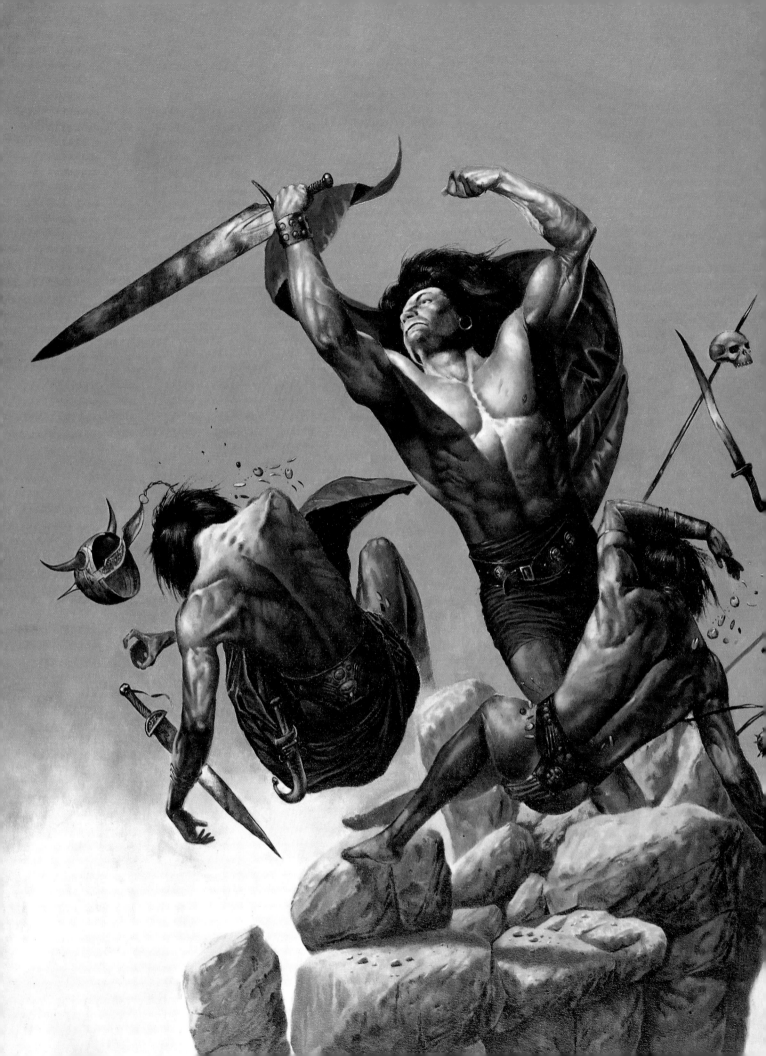

ON THE BORDERS OF CHAOS

In modern Fantasy a good example of the most extreme form of the Barbarian hero is Conan, who has rampaged through many books, films and comics and spawned a host of imitators. He is a fresh incarnation of many ancient heroes who likewise operated in conditions where the human foothold in existence is extremely precarious and the forces of Evil and Chaos can take on almost any monstrous form. Necessary talents of such heroes include immense strength, self-sufficiency and a scorn for any death other than an honourable one.

Indeed, glorious death is often their highest ambition since it will win their immortality in earthly legend and usually a place in some warrior's heaven like Valhalla. In the absence of any great outside peril this ambition often, unfortunately, also leads them to make war on each other for no great reason, something for which the ancient Celts are particularly famous though they were far from unique. In *The Iliad* it is hard to ignore the fact that the pretext for the Trojan War was pretty flimsy, and that most of the heroes would quite happily have fought side by side had some Asian horde come along to threaten them all.

Conan, The Liberator, Les Edwards.

15

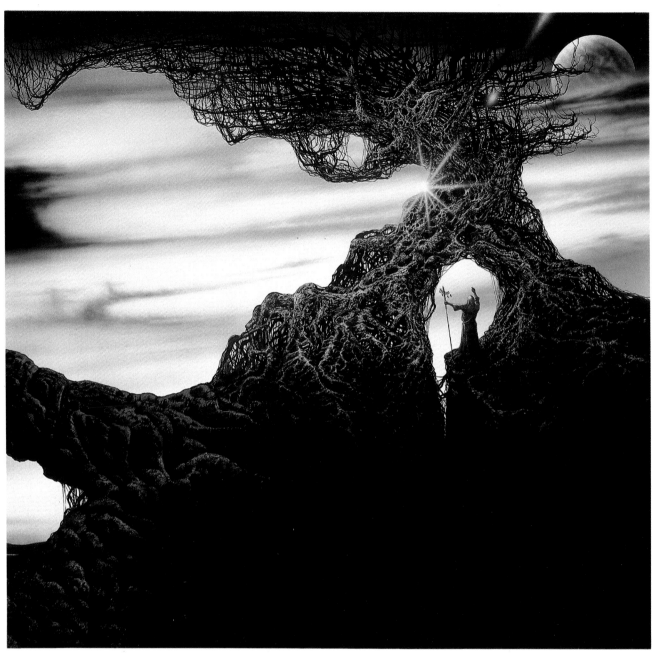

Spellsinger, Tony Roberts.

Cunning may often be needed too, but generally speaking moral dilemmas are rare in the Barbarian hero's world. The thing that needs doing is usually obvious, the only problem is how to achieve it.

Conan the Barbarian, created by Robert E. Howard and continued by various authors since, is quite closely modelled on ancient Celtic heroes of legend; as betrayed in the books by exclamations like 'Macha' (the Irish war-deity who was patroness of Ulster) and 'Manannan Mac Lir' (the Celtic sea god who gave his name to the Isle

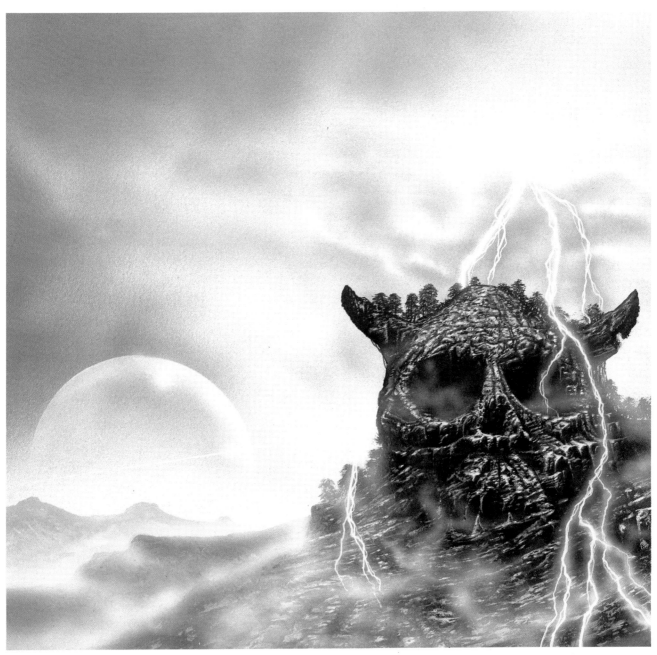

Planet of Death, Tony Roberts.

of Man). Conan's home, Cimmeria, is supposed to have existed approximately where the North Sea is now, bordered on the west by the Pictish Wilderness.

Although a Barbarian by birth and upbringing, many of Conan's adventures take place in lands that are civilised to the extent that they contain cities and empires, but the civilisations he encounters are generally decadent ones teetering on the brink of collapse and threatened by invading armies, monsters and malevolent supernatural

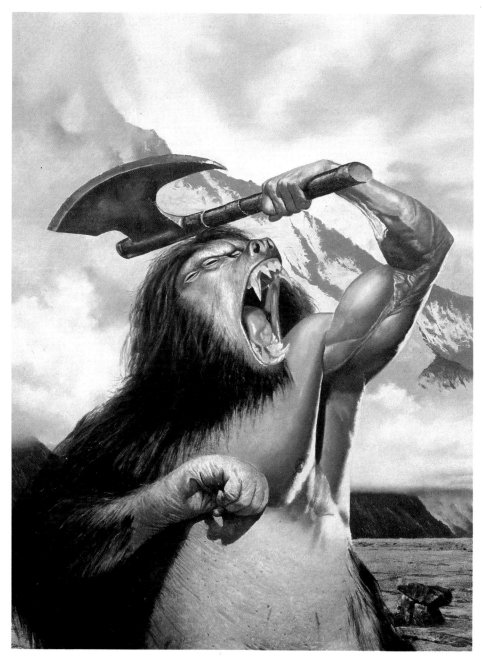

Berserker, Les Edwards.

powers, into which he bursts like a clean, cold wind from the north.

It is not hard to see the attraction of Barbaric heroes to people whose lives and goods are only as safe as their power to hold onto them, and where the world beyond their immediate environment is peopled almost entirely by their imagination, but why do heroes like Conan still fascinate a great many people in our modern, highly urbanised culture?

A possible reason is graphically expressed by an interesting comic-

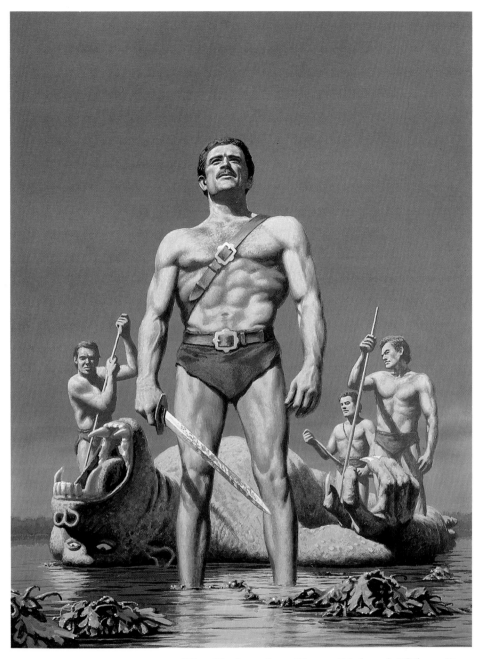

The Unforsaken Hero, Richard Clifton-Dey.

book variation of the type—the Incredible Hulk whose alter ego is a mild-mannered academic who undergoes a transformation into the monstrous green giant when the restrictions of civilisation get too much for him and he succumbs to rage.

Civilisation can be a mixed blessing since the price of security is very often a cramping of opportunity. In the Barbaric world death may be lying in wait around the next corner but so may be the chance of making one's wildest dreams come true. Civilisation may offer chal-

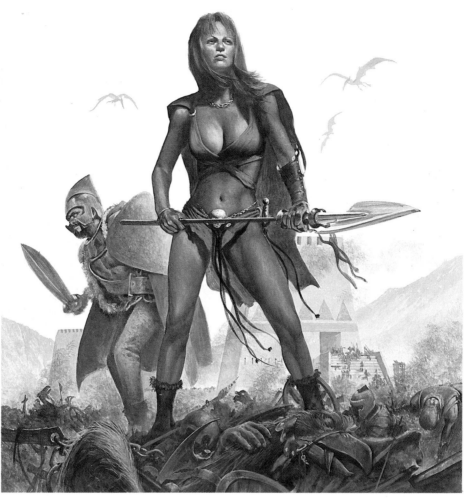

The Dragon, Dave Pether.

lenges and excitement enough to some but it is not surprising that others should dream of a freer environment in which strength, wit and daring are enough. After all, society itself may have changed dramatically over the centuries but humanity has not evolved notice-ably since before the dawn of history.

What Conan embodies better than the original heroes on whom he is based is the frustration of natural Barbarians born into an era which has little use for them except in times of war. His creator, Howard,

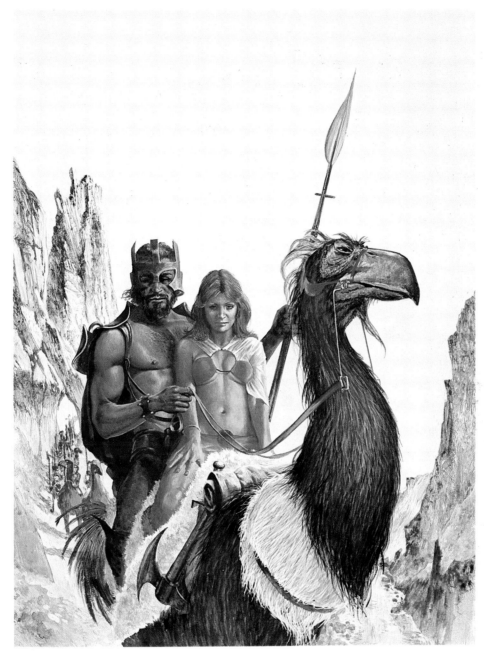

The Serpent, Dave Pether.

committed suicide at the age of thirty and one can't help thinking that his life story might be as intriguing as any of his most famous hero's, even though much of it must have been spent at the typewriter in view of his vast literary output.

Something Barbaric heroes also often possess is the favour of some divinity, usually as a result of kinship. In Greek myth, Heracles (Hercules) was the son of Zeus. In the *Song of the Niblungs* (the basis of Wagner's *Ring Cycle*) the hero Siegfried is the grandson of Wotan

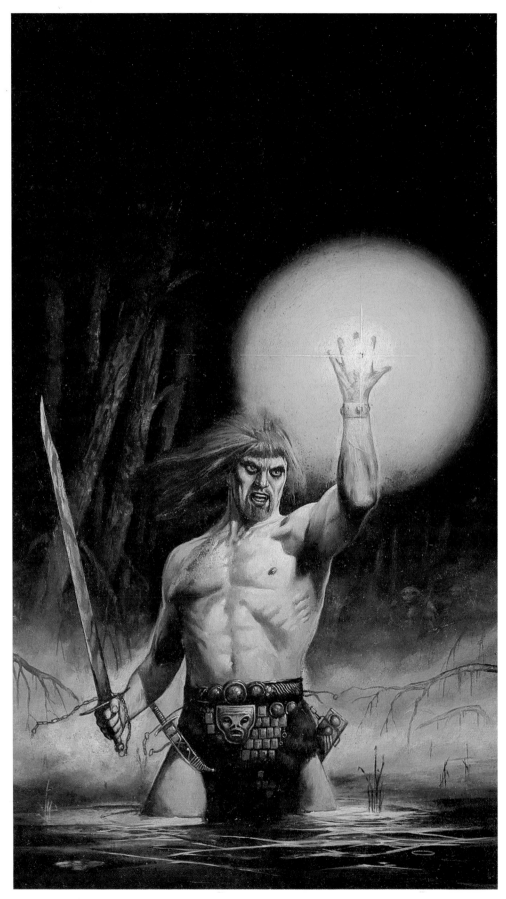

Bloodstone, Les Edwards.

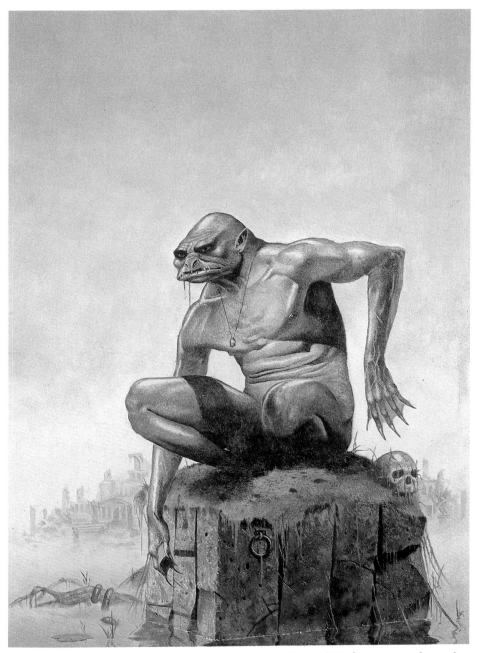

More Weird Tales, Les Edwards.

through both his parents, while the Irish hero Cuchulainn was at least the spiritual son of Lugh, the Celts' supreme god (the account of his conception is a little confused).

Cuchulainn, incidentally, among his many other attributes used to undergo an Incredible Hulk-like transformation when seized by his famous battle rage. Normally he was a comely youth with whom every maid fell in love, but when roused his whole body swelled up and contorted till he turned into a monster, his hair standing up in spikes

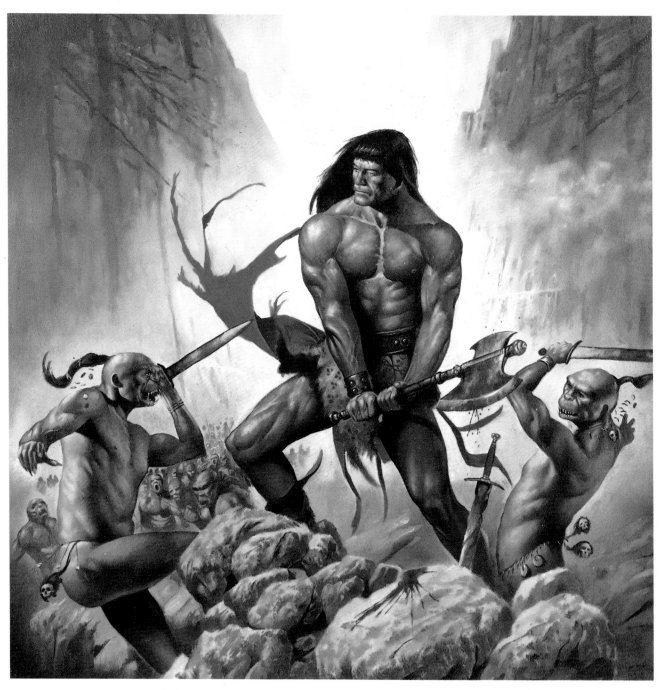

Conan, Sword of Skelos, Les Edwards.

so sharp that apples could be impaled on them. When the transmogrification was complete even his friends hid from him since his rage was a little indiscriminate. After one of his forays they had to plunge him into three cold baths in succession before his temper cooled enough for safety.

Cuchulainn is the hero of the *Tain Bo Cuailnge*, the Irish epic often compared with the *Iliad* in which he single-handedly defends his province of Ulster against an army gathered from the rest of Ireland by

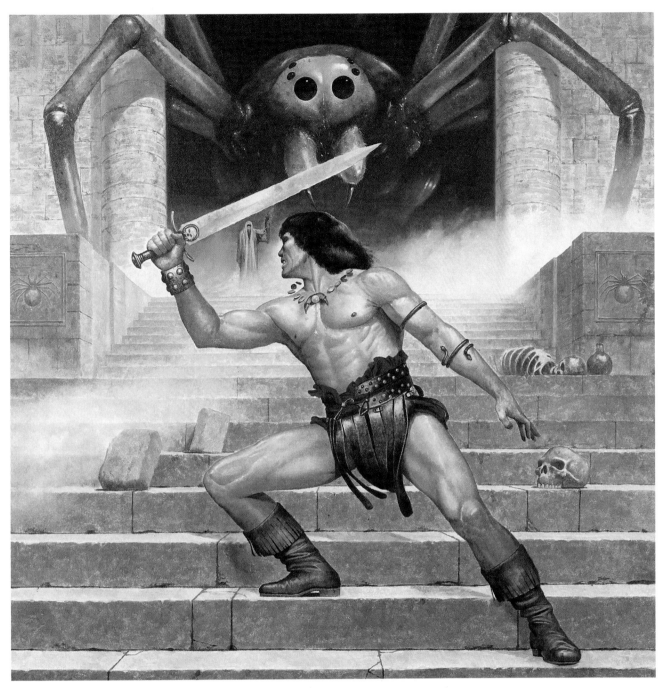

Conan, The Spider God, Les Edwards.

Queen Maeve of Connaught. The ostensible cause of the raid is that Maeve has set her heart on a marvellous Brown Bull which an Ulsterman has refused to let her have, but underlying this is plainly a long-standing grudge against the northern province held by the rest, coupled with the chance of doing a little looting and pillage along the way.

Unluckily for Ulster all its grown men have been struck by an enfeebling curse for offending their goddess Macha. The only cham-

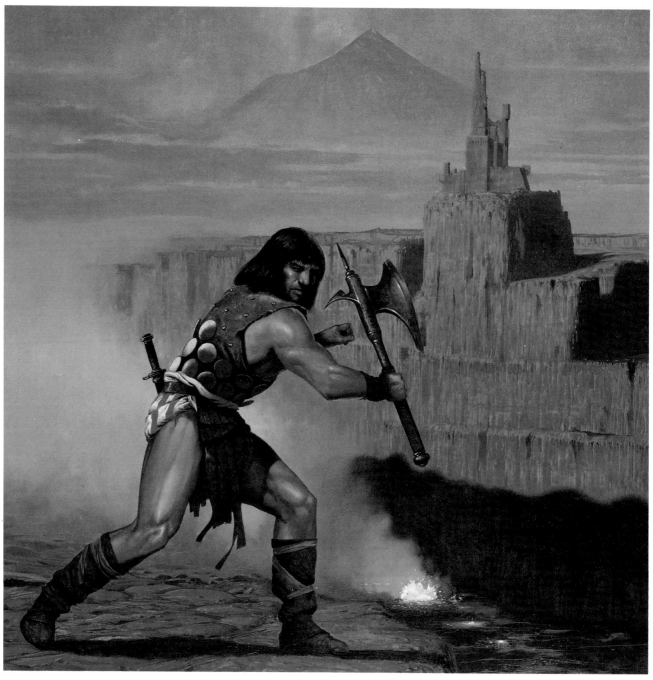

Conan, The Unconquered, Les Edwards.

pion left is Cuchulainn who escapes the curse because he is still only a youth.

Even such a hero as Cuchulainn has already proved himself to be cannot hope to defeat a whole army, but he does manage to delay its progress by challenging it at every ford and mountain pass. By a widespread heroic convention which surfaces in the Biblical story of David and Goliath, Maeve's army cannot simply trample over him but is obliged to either find champions to meet him in single combat or else take another road.

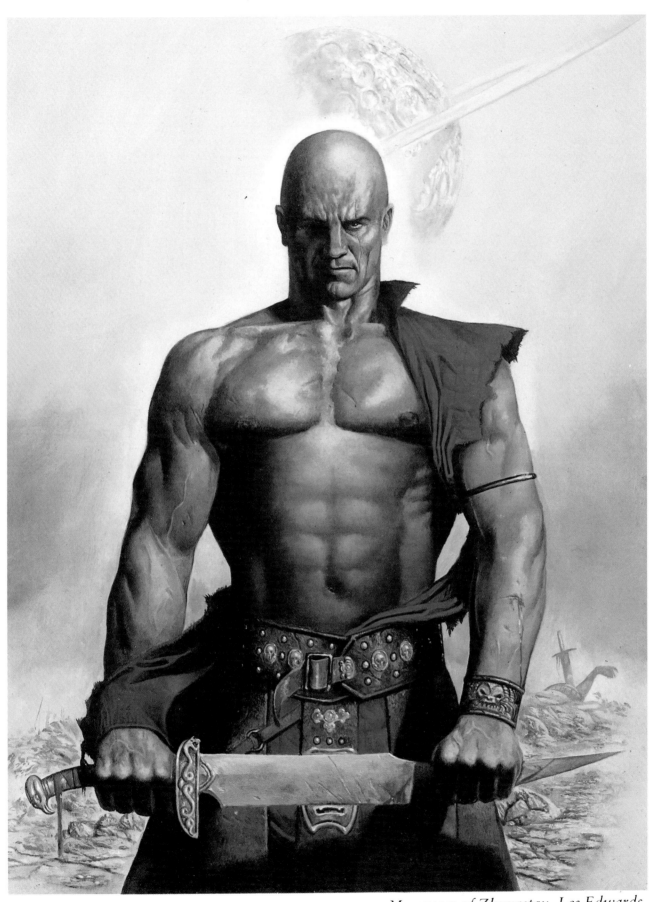

Messenger of Zhuvastau, Les Edwards.

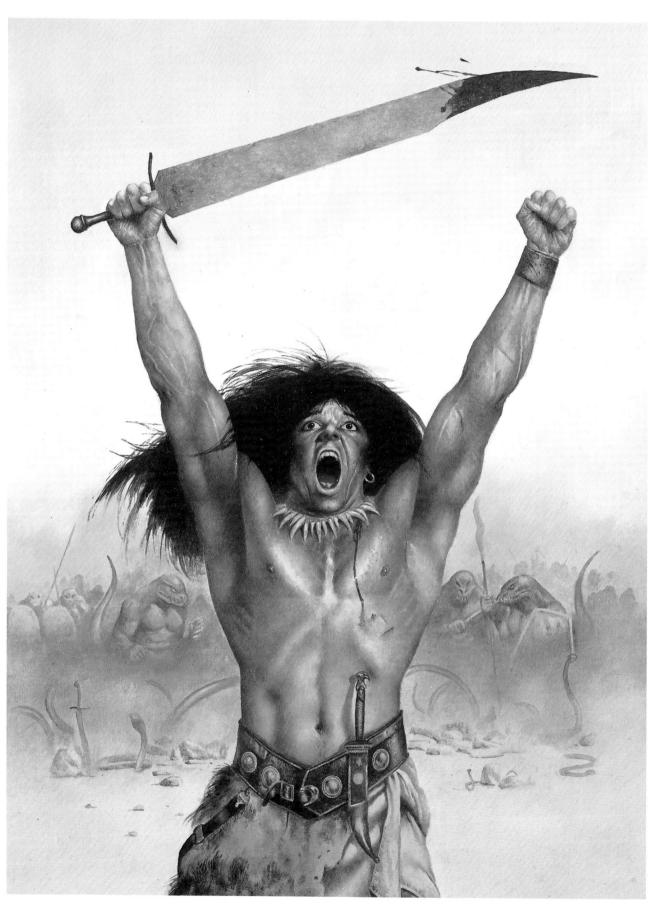

Wizard of Lemuria, Les Edwards.

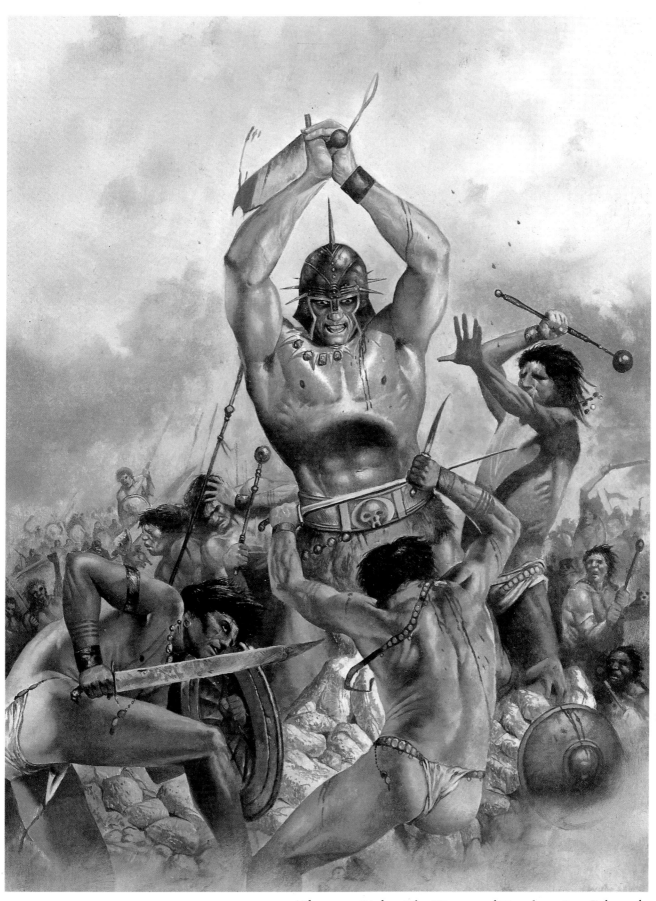

Thongor Fights The Pirates of Tarakus, Les Edwards.

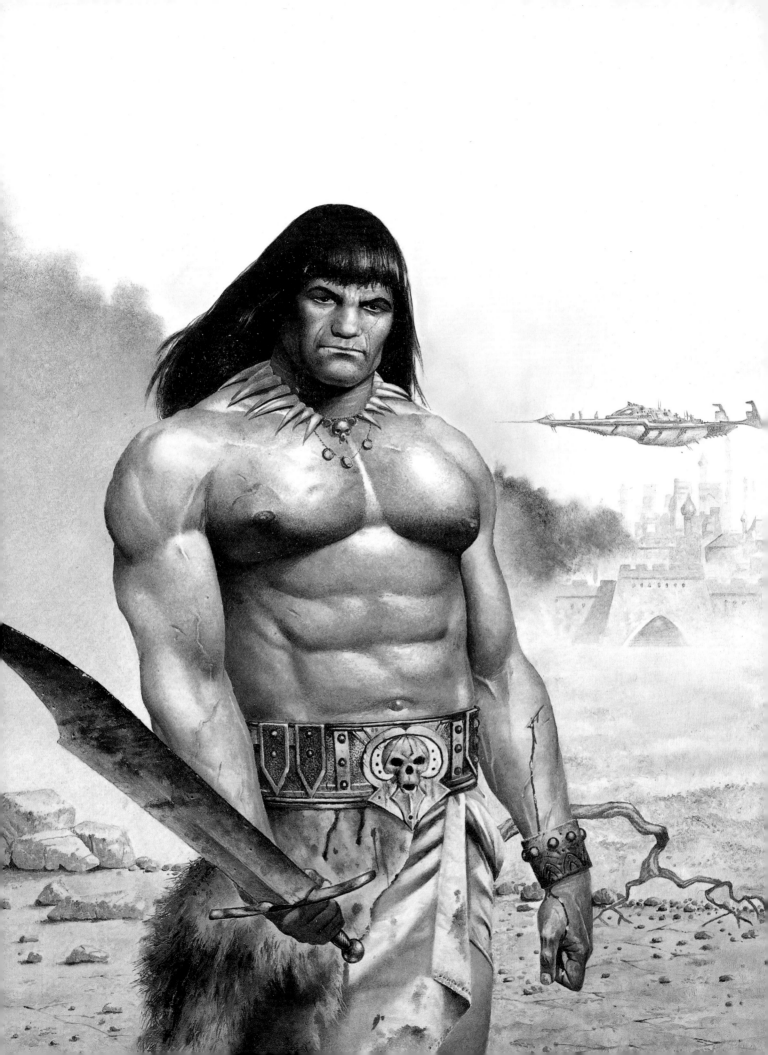

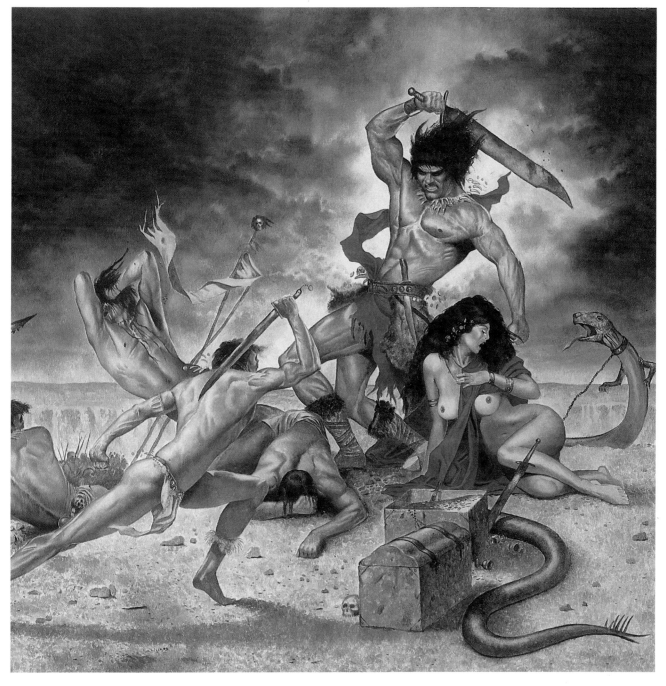

Conan, Les Edwards.

Since he is unequalled in single combat, Cuchulainn succeeds by this means in delaying the army for several months until finally, when he has come to the end of his strength, the curse lifts and the men of Ulster come storming south to teach Maeve a lesson.

Strict adherence to a code of honour is characteristic of Barbaric heroes. In the Tain the villain of the piece, Maeve, is frequently tempted to have troublesome Cuchulainn simply overwhelmed but is

Thongor, The Wizard of Lemuria, Les Edwards.

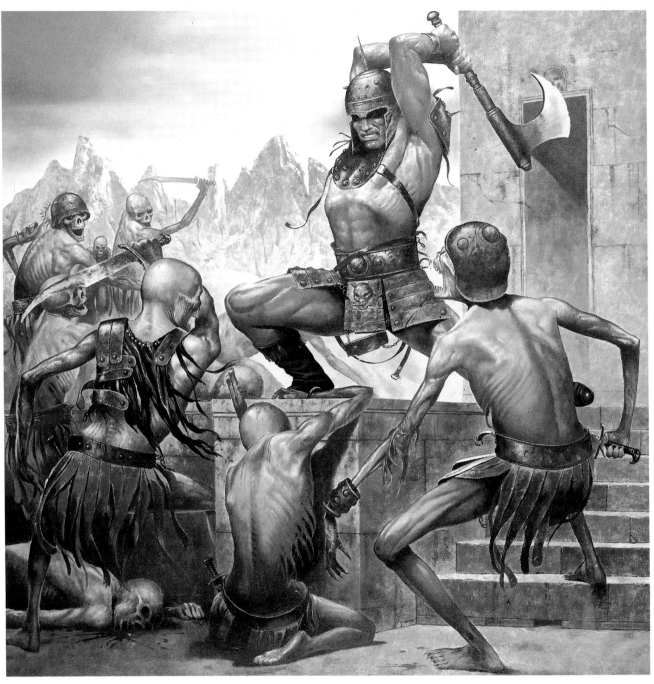

Conan, The Rebel, Les Edwards.

prevented by her own followers on grounds of honour. The fact that she tries in secret anyway is what makes her the villain more than having raised the army in the first place, which is something that any high-spirited Barbarian might think of.

This sense of honour can, however, cause problems for a hero, especially when coupled with rash vows. Often it leads to friends being obliged to kill each other because they have committed themselves to opposite sides in a dispute.

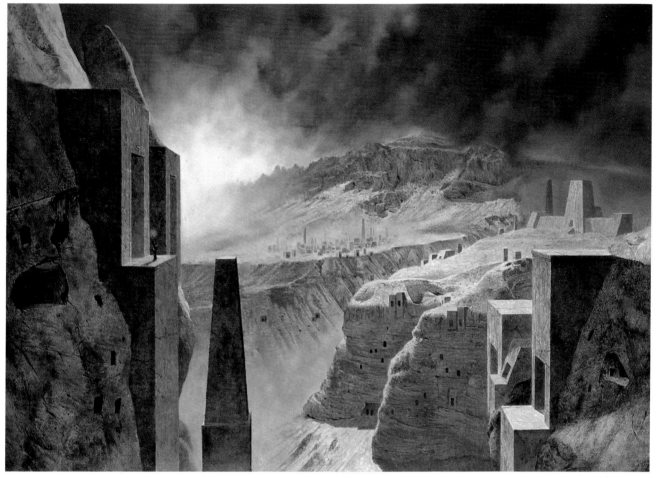

Tomb World, Les Edwards.

In Cuchulainn's case it led to him killing his own son. He had made the boy vow to reveal his name to no-one, make way for no man and refuse no man combat. The child grew up abroad away from his father and when they eventually met Cuchulainn challenged him, as was the custom, to reveal his name or die. . . .

While such tragedies may cause Barbaric heroes grief, they are generally accepted fatalistically as being the inevitable price occasionally demanded for heroism. To understand this one has to remember

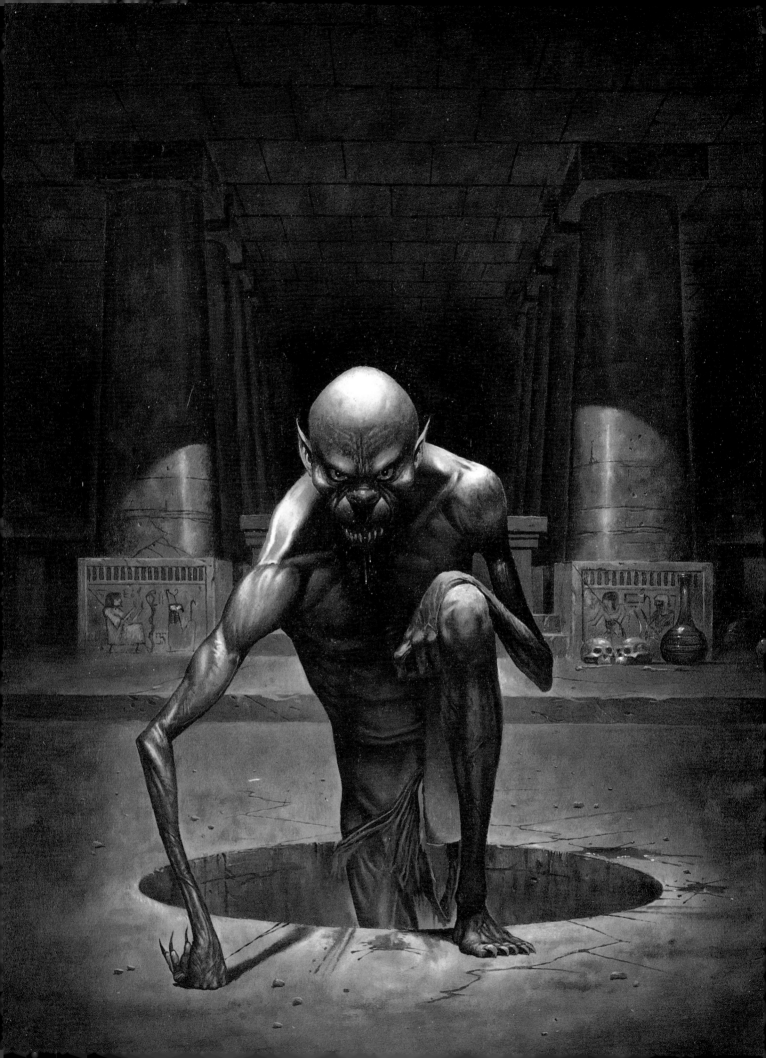

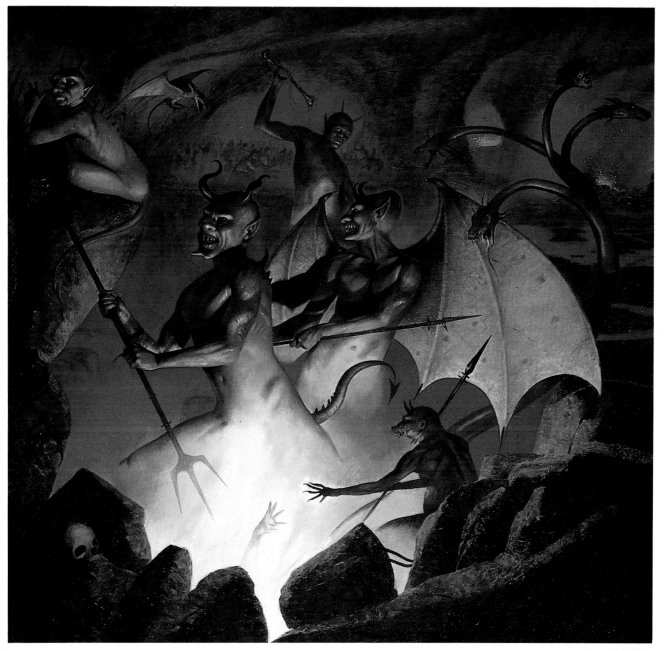

Hot Favourites, Les Edwards.

that to such heroes death is less important than honour, which means fulfilling one's vows at any cost, and that battle is their trade. Cuchu-lainn and his son each realised who the other was while still fighting, but by then it was too late to turn back.

The attraction of Fantasy and Science Fiction is that they open to the imagination vast new scopes of possibility in a world that to many seems cramped and bleak and mean under the harsh light of discovery. In ancient times the canvas was provided by the Unknown which

The Ghoul, Les Edwards.

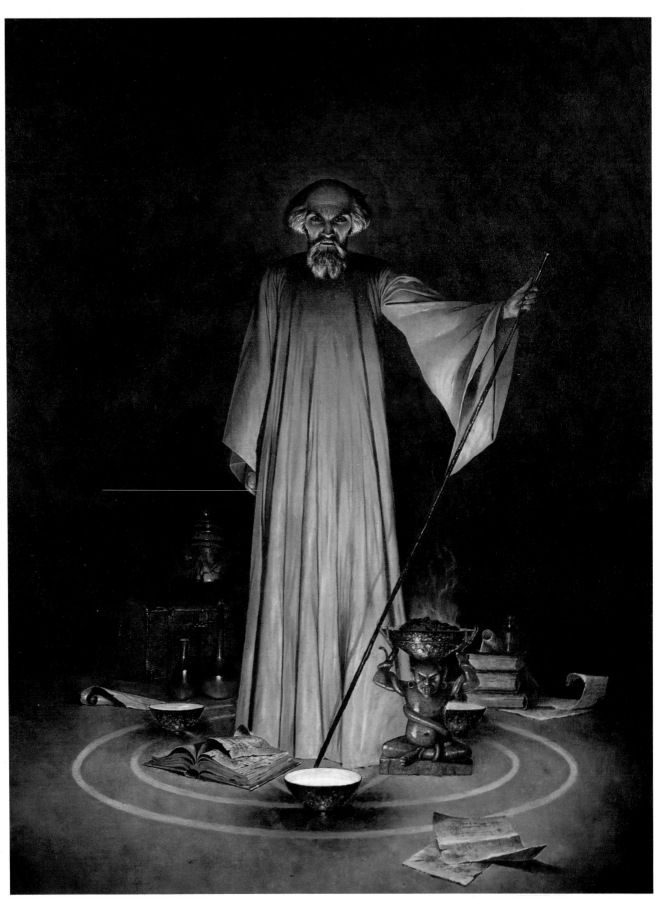

Absolute Power, Les Edwards.

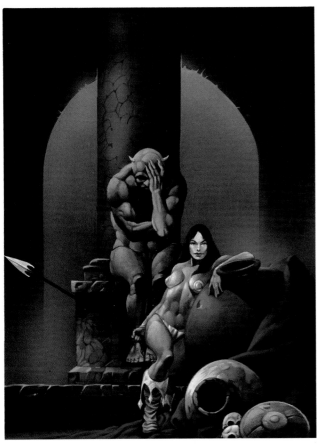

Palace of Despair, Robin Hidden.

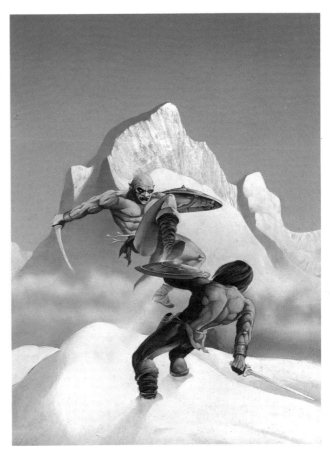

Realm of The Ice Lords, Robin Hidden.

crowded in on all sides. Humanity tried and succeeded in pushing back the frontiers of the known world and discovered that if you explore far enough you arrive back at your starting point by way of the Earth's circle; and on the way all kinds of marvels have been discovered, yes, but where are all the sirens and serpents and sorcerers who filled the Unknown before? What has become of the Fountain of Eternal Youth and the magic lamp that grants every wish? Somehow they have all vanished, but if such things never truly existed, where did the idea of them come from?

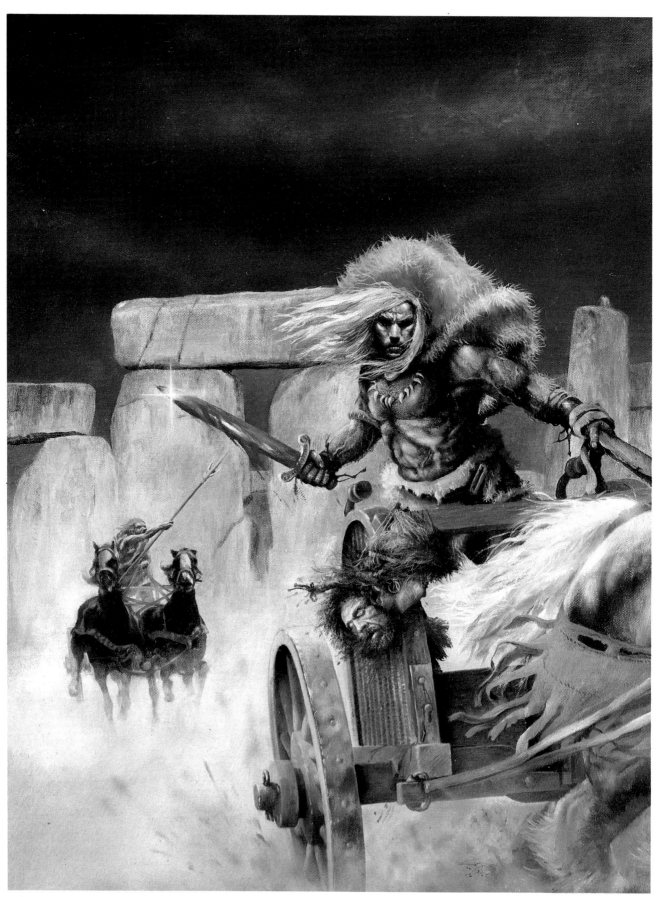

The Power of The Serpent, Jim Burns.

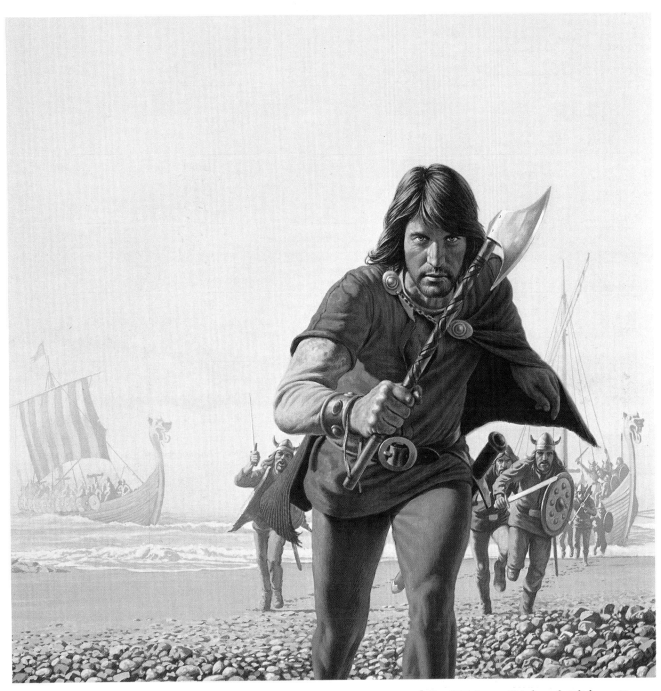

The Vikings, Richard Clifton-Dey.

It is almost as if we are born into this world with knowledge of others. When as children we read of witches and dragons and castles in the sky, we accept them as real because they chime with something inside us. Sceptics might argue that it is the other way round, that children accept these things because they have yet to learn what is possible and what is not; but for all their ignorance most children are not fools. They can usually tell when a story makes no sense and is

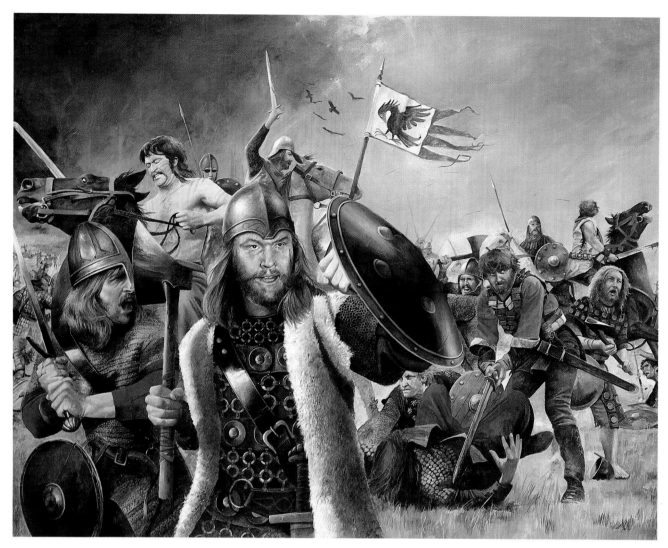

Dane Gold, Chris Collingwood.

simply trying to play on their gullibility. Dragons make sense because they resonate with an inborn idea of such creatures, as shown by the appearance of dragons in the folklore of disconnected cultures all over the world. The details of appearance may vary in each culture but the essence is the same. To prove that dragons and the rest have never existed is very often to miss the point, which is that if they never have existed on Earth why has the human imagination so often insisted that they do? And where else might they exist?

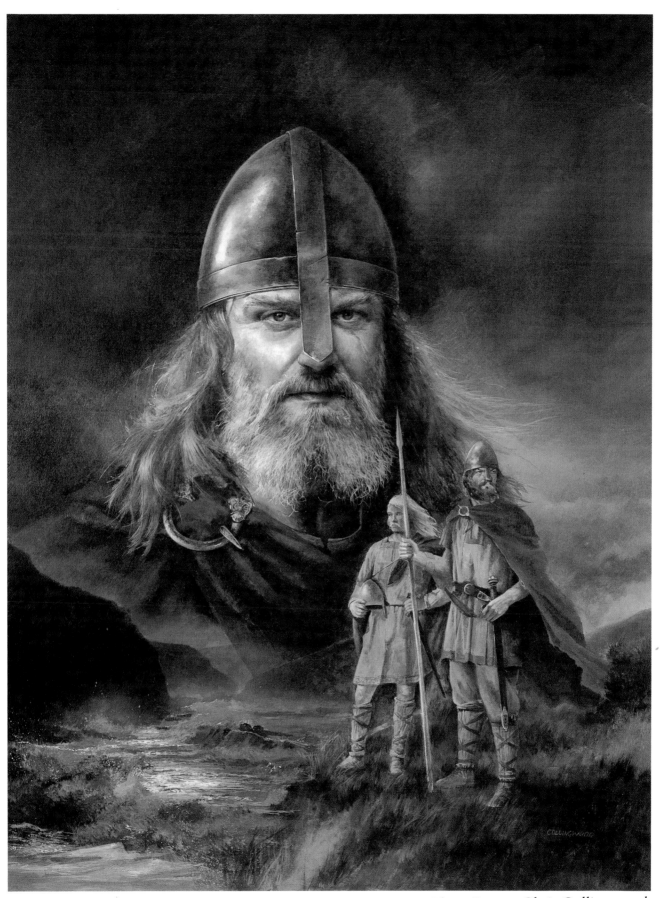

Viking Poster, Chris Collingwood.

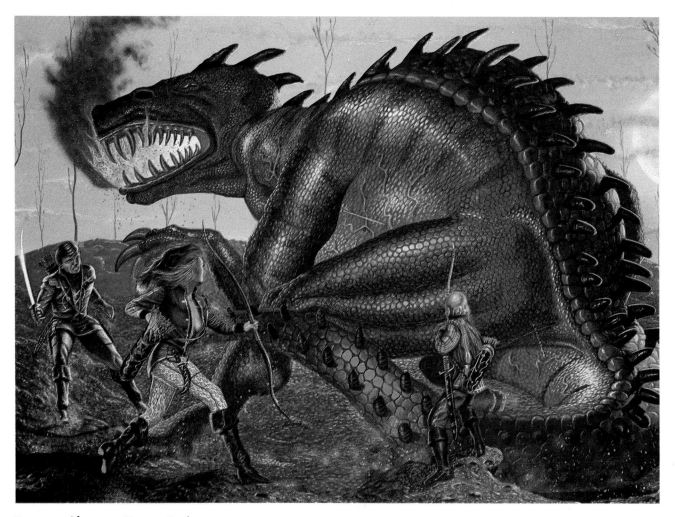

Dragon Slayers, Terry Oakes.

Science Fiction has often suggested possible answers, though this has become less common. There is a distinct trend away from the monster and marvel-filled tales which once filled pulp magazines. Science Fiction and Science seem, in fact, to be converging but there is still a place for the old-fashioned kind of monster tale—as shown by the success of the film *Alien* whose plot might have been lifted from any of a hundred 1930s stories, though this is obscured by the stunningly persuasive effects, acting and directing.

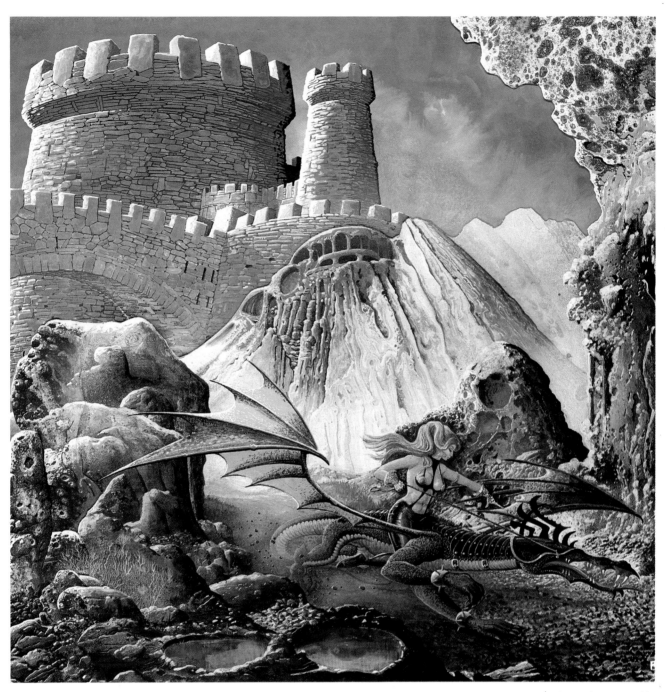

The Hoard, Bob Layzell.

A recent parallel with tales like the *Tain Bo Cuailnge*, though without most of the supernatural elements, is the body of legend which sprang up around the taming of the Wild West in America and which continues to grow and develop. Similar codes of honour apply to gunslinging heroes (in fiction at least) and similarly tall tales are told about their prowess—such as Davy Crockett and the unlucky bear he tangled with when hardly out of nappies.

As in the ancient legends, a canon of heroes has evolved, each with

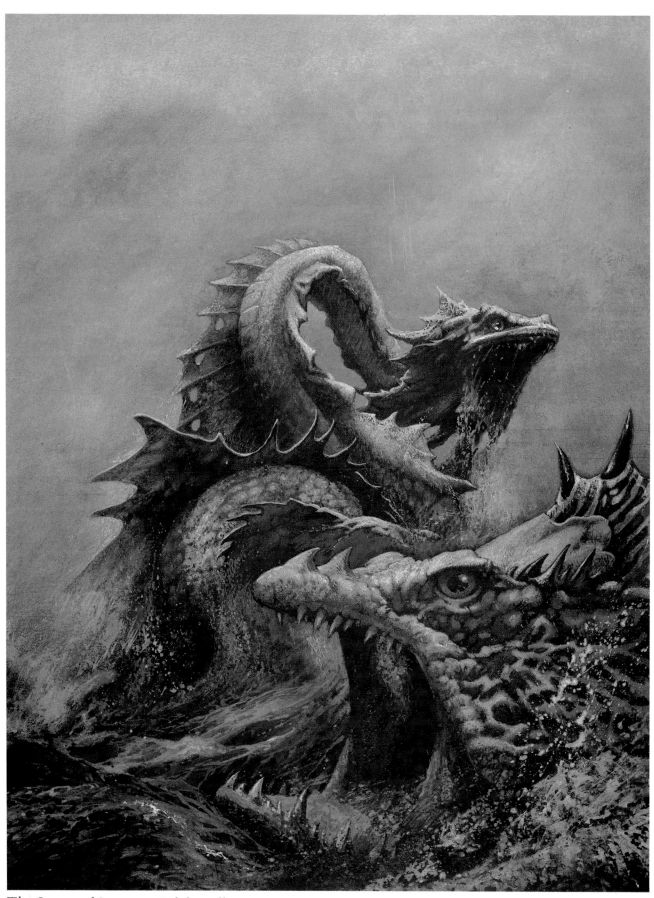

The Songs of Summer, Julek Heller.

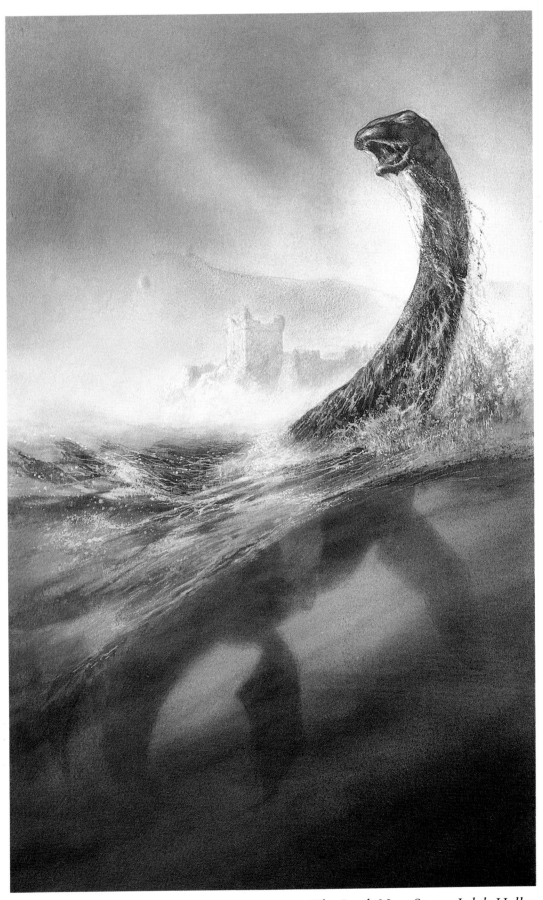

The Loch Ness Story, Julek Heller.

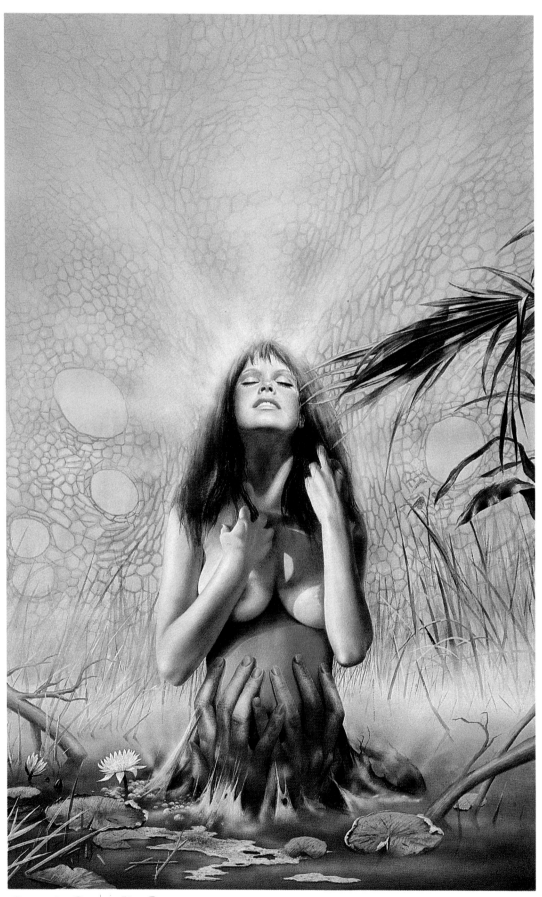

Gwen in Green, Jim Burns.

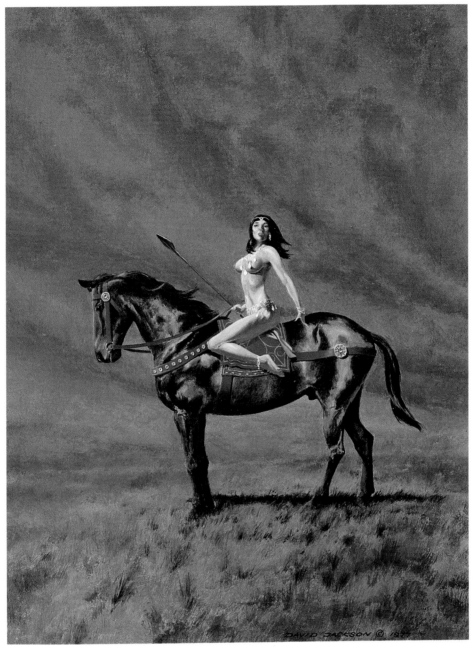

Barbarian Queen, David Jackson.

certain attributes which would probably astonish the originals could they see what they have been made into.

Not all Wild West heroes are Barbaric ones, of course, but many are and it is not uncommon that their tales end with a sting of regret. When he has made the town safe for decent citizens and the Federal Marshal moves in, the hero often grows uncomfortable. In a tamed environment he becomes an anachronism, even something to be feared by the very people he has saved, and so he has to ride on further west.

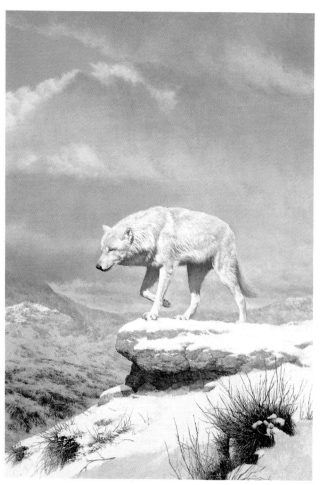

Never Cry Wolf, Gordon Crabb.

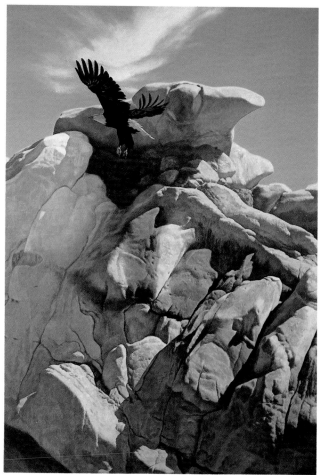

Pacific Rock, Gordon Crabb.

The Barbaric hero's problem is that he enjoys the battle against evil or anarchy and if he is too successful he destroys his own reason for existence. He may fight on the side of civilisation against Chaos but he is himself half in love with Chaos, a creature of the wild who is choked by the order he helps to impose.

Within more of us than will admit, there lurks an unreconstructed Barbarian, however much in reality we cling to such comfort and security as lie within our grasp. In dreams and fantasies even the

In The High Country, Gordon Crabb.

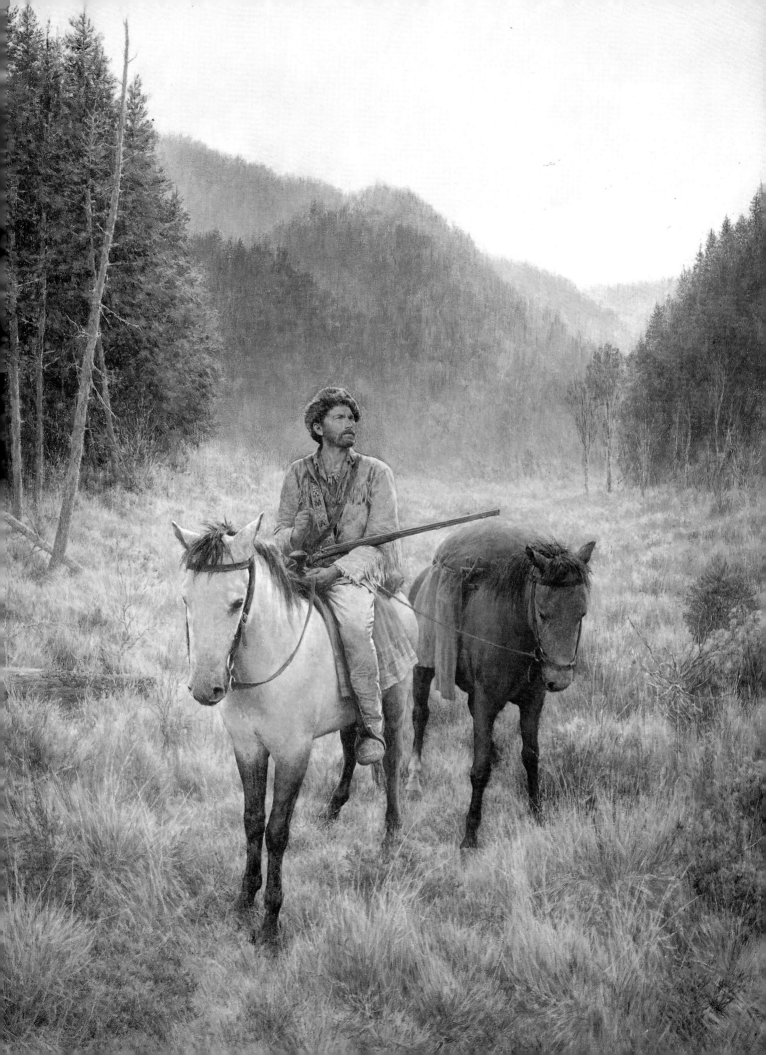

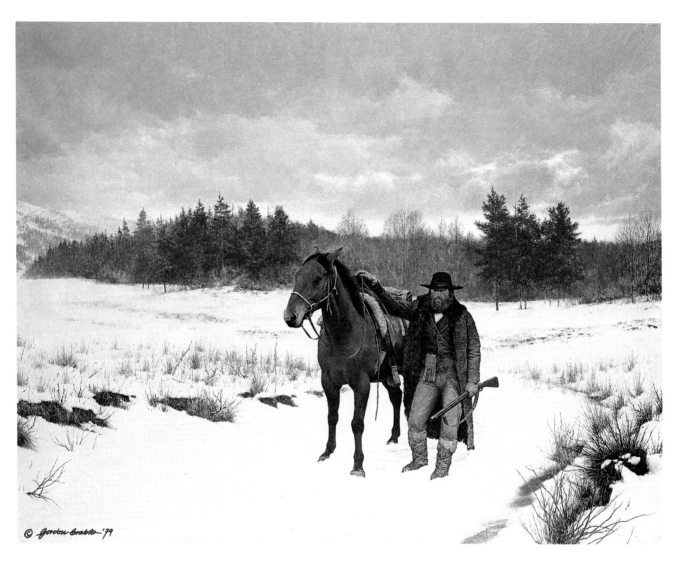

Nebraska, Gordon Crabb.

mildest-seeming of mortals (in fact, quite commonly it is they) may imagine themselves striding fearlessly through nightmarish worlds confounding their enemies, bringing justice to the oppressed (particularly those of the opposite sex) and chancing their lives with a quip and a careless laugh. There is not necessarily anything unhealthy in this, it is merely a sign of character. Different dreams appeal to different people, the common mistake is to assume that one's own are secretly shared by everyone else. Or, worse still, that they should be.

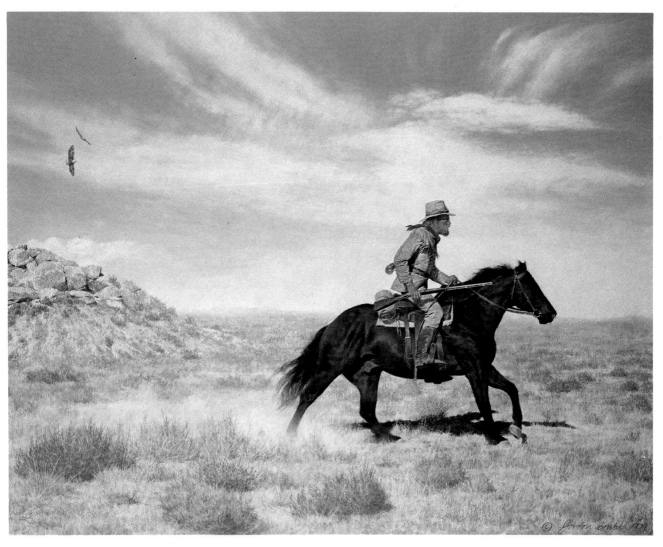

Wyoming, Gordon Crabb.

Fantasy on the whole provides a better home for monsters and mythical creatures than Science Fiction since it has not the same obligation to provide a 'scientific' basis for their existence.

This is not to say that there are no rules about what is possible in Fantasy. On the contrary, there are very strict rules which, if ignored, will destroy the credibility of a tale or picture, but they are not scientific. The difference between *The Lord of the Rings* and countless creaking imitations of it is that Tolkien understood intuitively and by

51

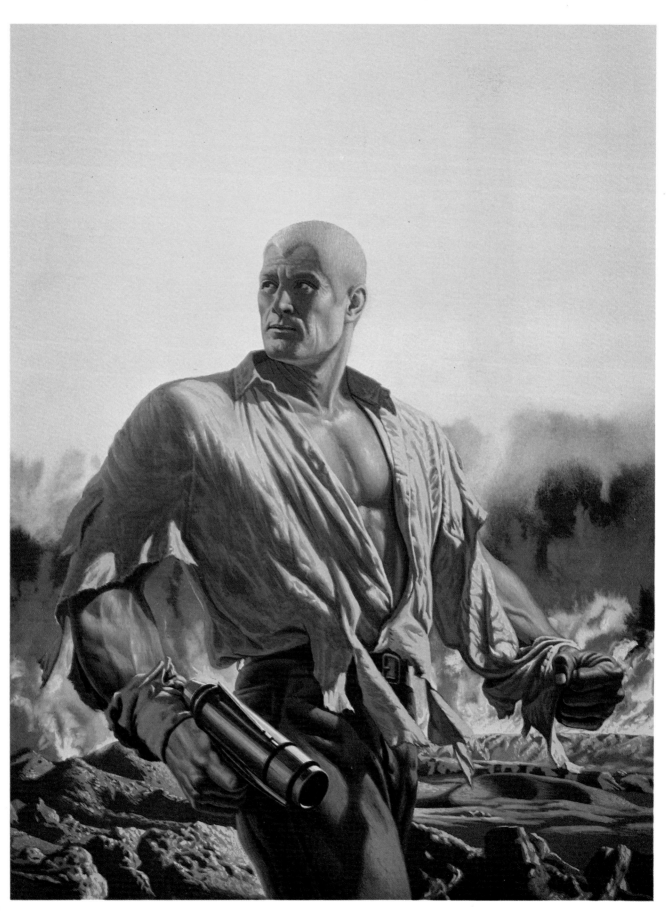

Doc Savage, Richard Clifton-Dey.

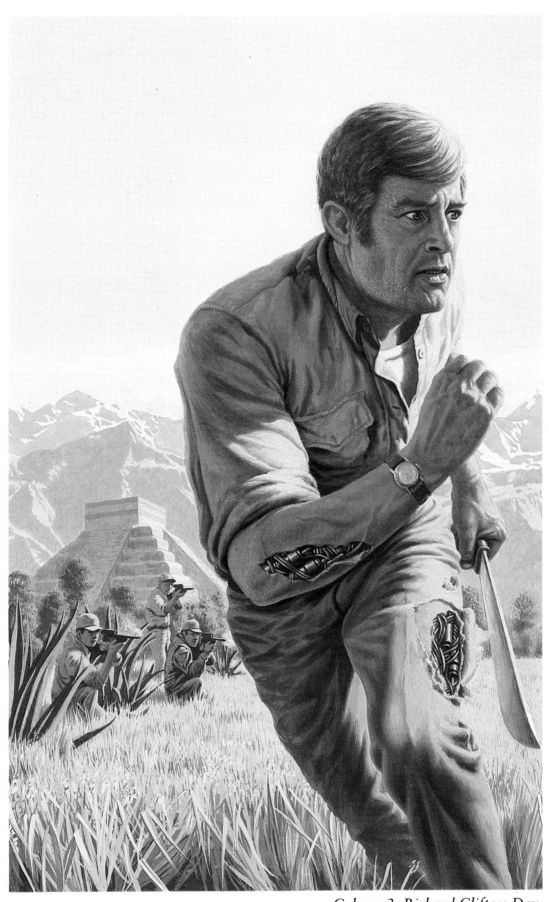

Cyborg 3, Richard Clifton-Dey.

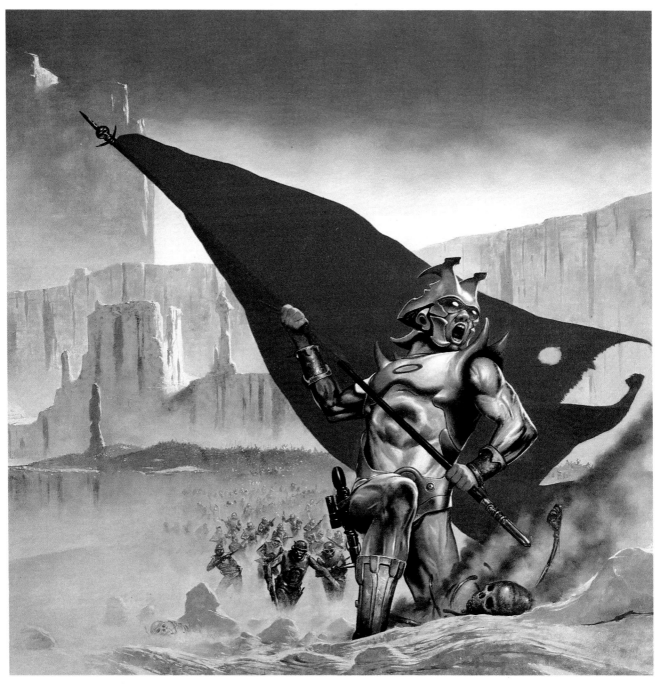

The Final Encyclopedia, Les Edwards.

drawing on ancient legends how goblins, elves, wraiths, talking trees and the rest would behave given the chance of existence.

Not all Barbaric heroes are in the Conan mould and not all their worlds are quite so tumultuous. Barbaric heroes often adapt to the conditions they find themselves in (when they don't cross the line and become villains). Very often they disguise their true nature when it does not suit the ideals of their culture and are mistaken for a different kind of hero, but one thing is certain—they will be found wherever

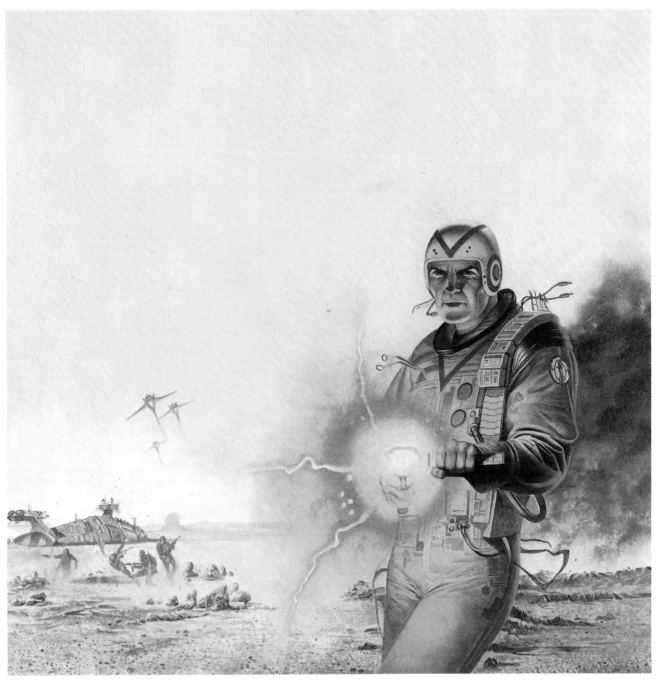

Planet of No Return, Les Edwards.

there is a lawless frontier and are usually distinguishable by being lone wolves.

Sometimes heroism is not enough. When Caesar conquered Gaul it was not because of the greater heroism of his troops. In fact the reverse is true if one applies the Gallic standards of heroism. He succeeded largely because he played the game of war by different rules.

A weakness of the Barbaric code of honour is its emphasis on the individual and the fact that victory counts for less than heroic glory.

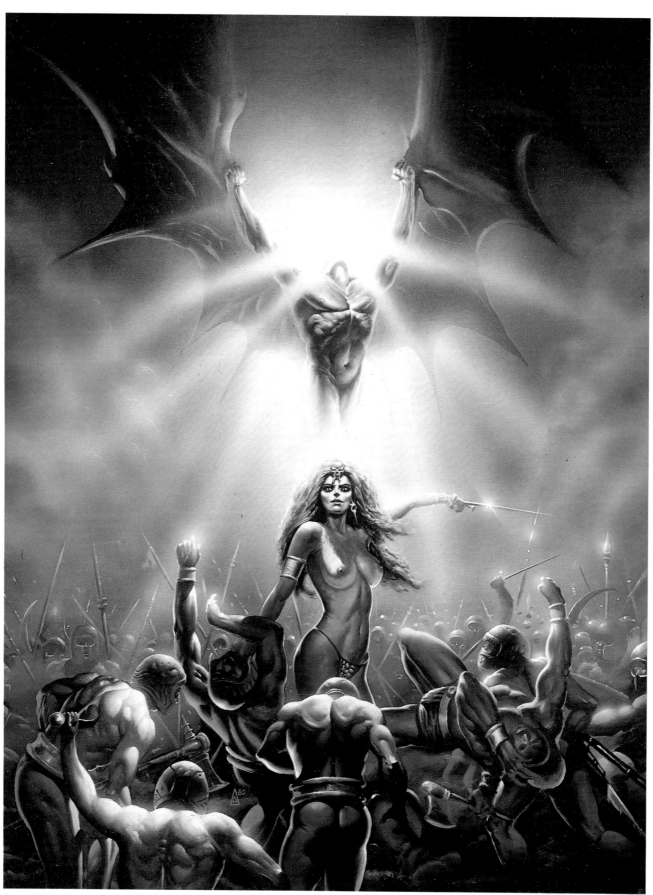

Well of Shiuvan, Alan Craddock.

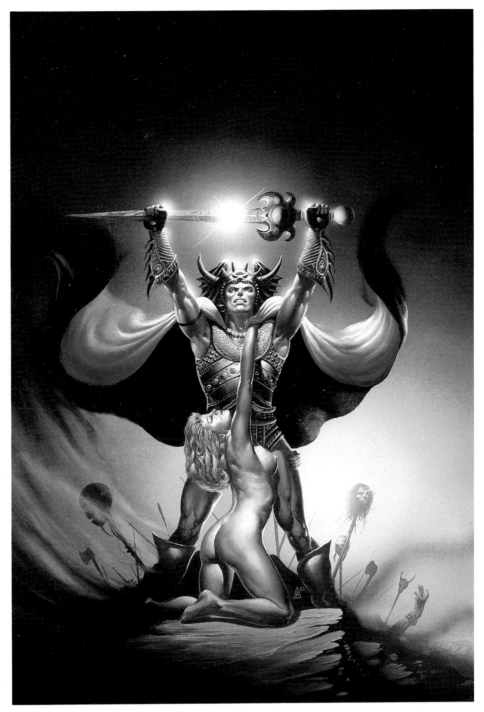

Door into Fire, Alan Craddock.

Before Caesar's arrival the Celts of Gaul had little time for battle tactics because a battle was seen essentially as a clash of heroes on a one-to-one basis. Whatever the stakes, battle was a formal contest, a sport almost, in which warriors fought for their own renown as much as their adopted cause, and a fallen enemy was as likely to be honoured afterwards as an ally.

Remnants of this code lingered on among the Romans but in practice the basic premises were reversed. To Caesar victory was the

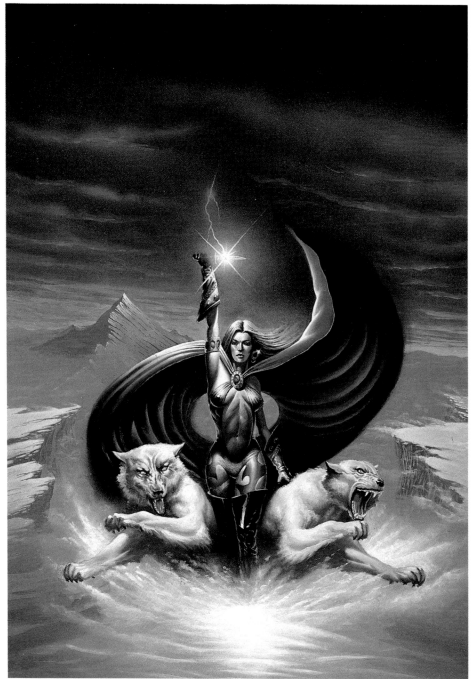

Lady of The Haven, Alan Craddock.

prime goal and the individual heroism of his troops counted only if it fitted into the grand design of his campaign. Time and again he ordered his troops to run from the enemy as if afraid and so lure them into a trap. To the Gauls such cowardice was unthinkable even if it might secure victory. The price they paid for their pride was slaughter and defeat.

Mind you, the Roman soldiers themselves were not always very

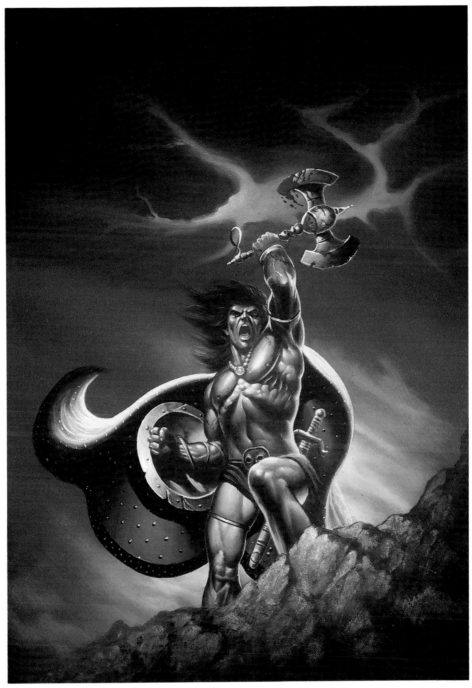

Bloodaxe, Alan Craddock.

happy about running away from the enemy. As individuals they were not so very different from the Gauls and probably nurtured much the same heroic dreams in private—but as Romans they had to do what they were told. They had surrendered their individuality to the Roman fighting machine. In Celtic eyes this reduced them to little more than serfs, but constant defeat forced the Gauls to try and revise their standards.

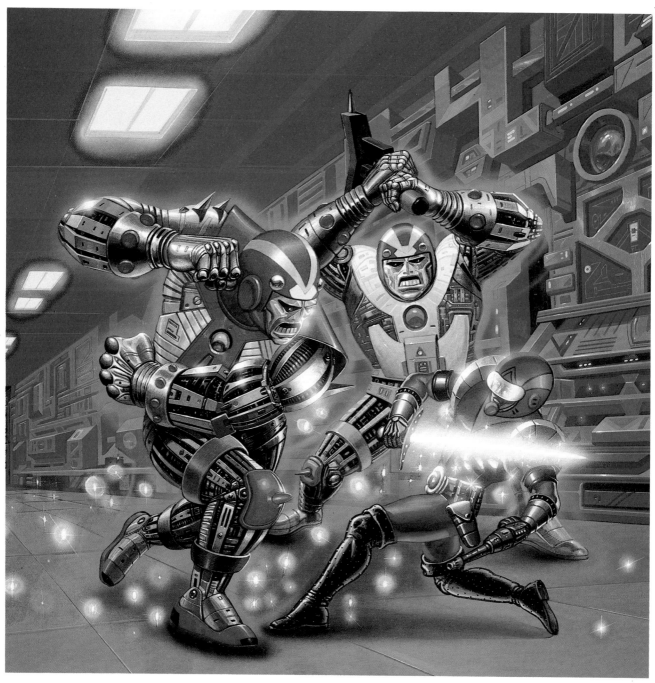

Heroes 1, Alan Craddock.

Under Vercingetorix the clans united and tried to co-ordinate their attacks on the Romans. Through superior numbers they very nearly succeeded in smashing the invasion but old habits died hard. In the end an inability to follow up their victories opened the way to disaster.

There is a paradox in the tale of Caesar's conquest of Gaul. While in the broad sweep of history it appears to be a clash between a civilised

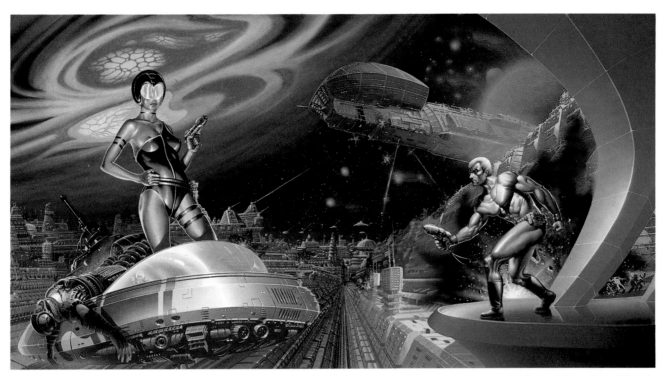

Slippery Jim Digriz 2, Alan Craddock.

culture and a barbaric one and was seen by many Romans at the time
(and many Gauls of later generations) as the propagation of the
blessings of civilisation to a benighted people, those blessings were not
at all apparent on the expanding frontier. The laws which in Rome
would bind the Barbaric impulses of any Roman soldier in a net of
social responsibility almost as sophisticated as our own, were on
the frontier reduced to little more than an obligation to obey their

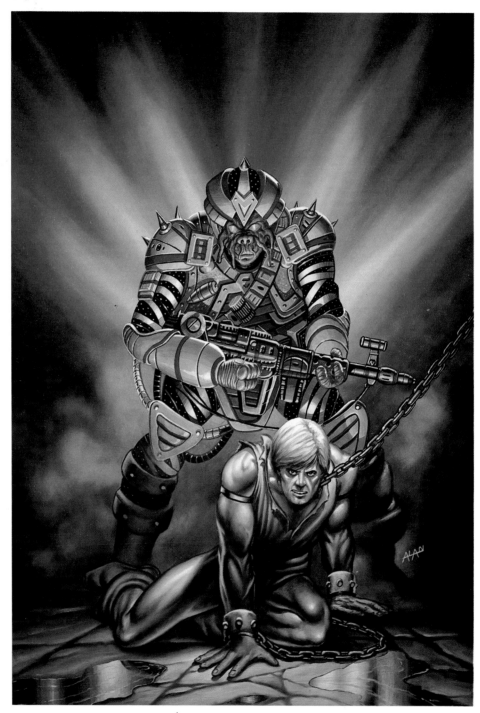

Hoods Army, Alan Craddock.

superiors. Ultimately this meant obedience to Caesar who, in his early career, is a good example of the Barbaric hero in disguise. He even betrays this in his journals by occasional disparaging remarks about the docility of ordinary Roman citizens in comparison with the fiery self-assertion and pride of most Celts; though it never seems to have occurred to him that this might be a reason for leaving them alone.

In the broad historical context the Roman conquest of Gaul was a

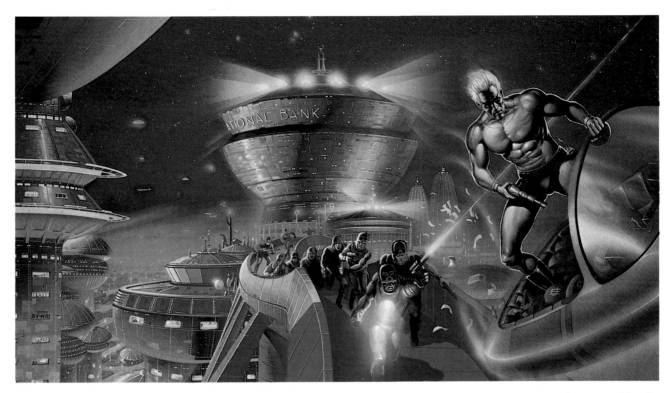

Slippery Jim Digriz 1, Alan Craddock.

clash between a civilised culture and a barbaric one, but in its throes it was simply a clash between two Barbaric impulses playing by different rules. If Rome had recognised this a little better it might have saved itself a good deal of trouble by keeping Caesar busy with further conquests instead of allowing the eye of his ambition to stray back to the hub of Empire.

The natural place of the Barbaric hero is on some lawless frontier

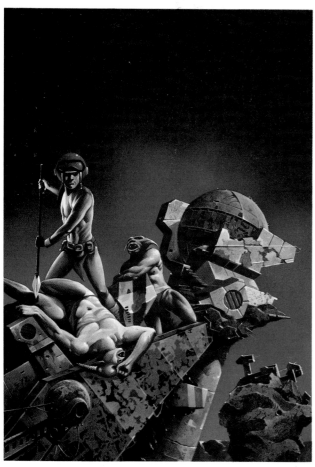

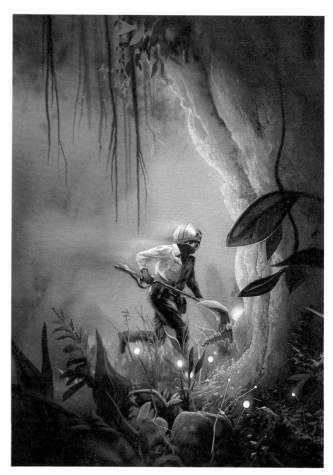

Twilight of The Gods, Robin Hidden.　　　　　　　*No Rest No Peace, Ian Craig.*

where his energies may be harmlessly directed outwards (harmlessly, that is to say, as far as his own people are concerned). Anywhere else he is quite likely to become a troublemaker. His problems in coming to terms with the order he helps create are clearly shown in many American films where displaced and often monosyllabic frontiersmen wander bewilderedly through modern concrete jungles looking for a cause and plainly wishing they had been born a hundred years earlier.

The channelling of Barbaric impulses into empire-building of one sort or another is a well recognised feature of most cultures which have carved themselves a secure place in the world. The Vikings are a

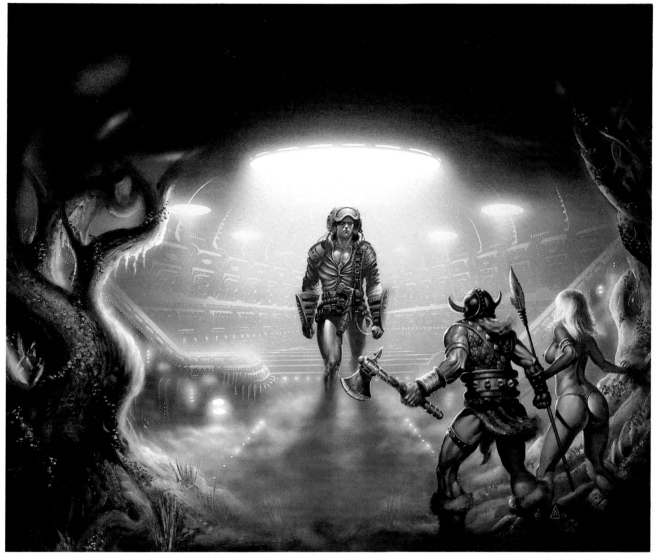

Technicolour Time Machine, Alan Craddock.

particularly vivid example because of the extreme contrast between the ferocity of their summer raids and the humaneness of the laws they observed at home or in any place where they actually settled—such as the Isle of Man.

As mentioned earlier, the problem arises for both the Barbaric hero and his people when there is no such frontier for him to be packed off to.

In the absence of any enforceable legal code to restrain its wilder heroes, the Medieval age invented Chivalry. Although there is a quantum leap between the two ideals, the second is very much a refinement

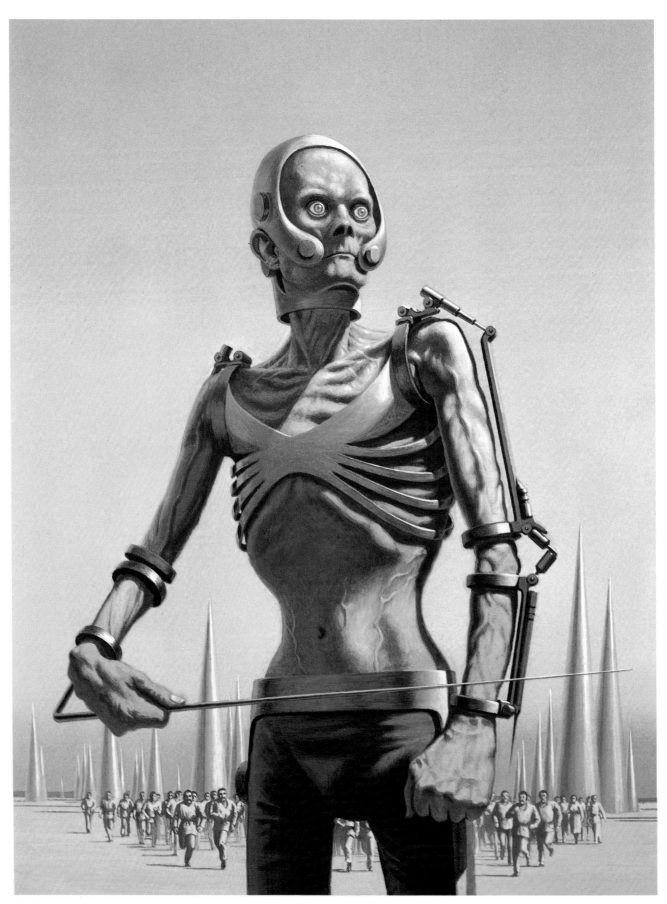

A Spectre is Haunting Texas, Richard Clifton-Dey.

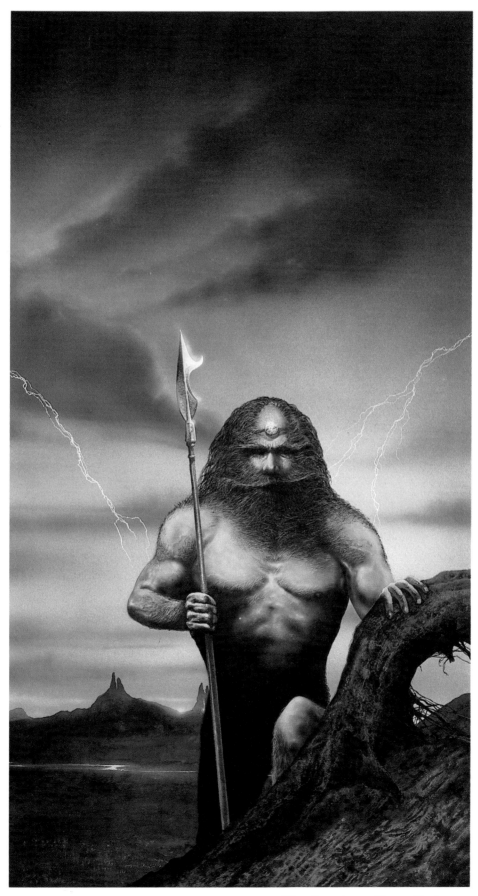

The Survivor, Tony Roberts.

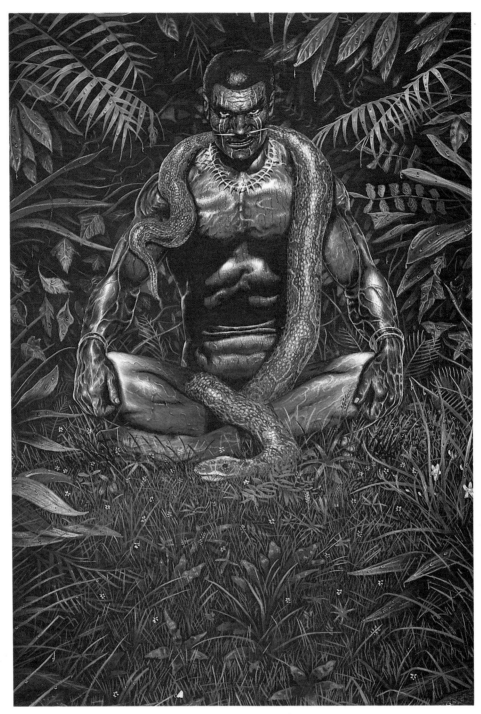

Revenge of The Medicine Man, Terry Oakes.

and differentiation of the first. In the end the new values depended on
champions able to impose them by force of arms on Barbaric terms if
need be.

In practice, peer pressure was often enough — as shown when Gawain
began to display distinct throwback tendencies soon after his election
to the Round Table. He was brought into line simply by being made to
feel ashamed.

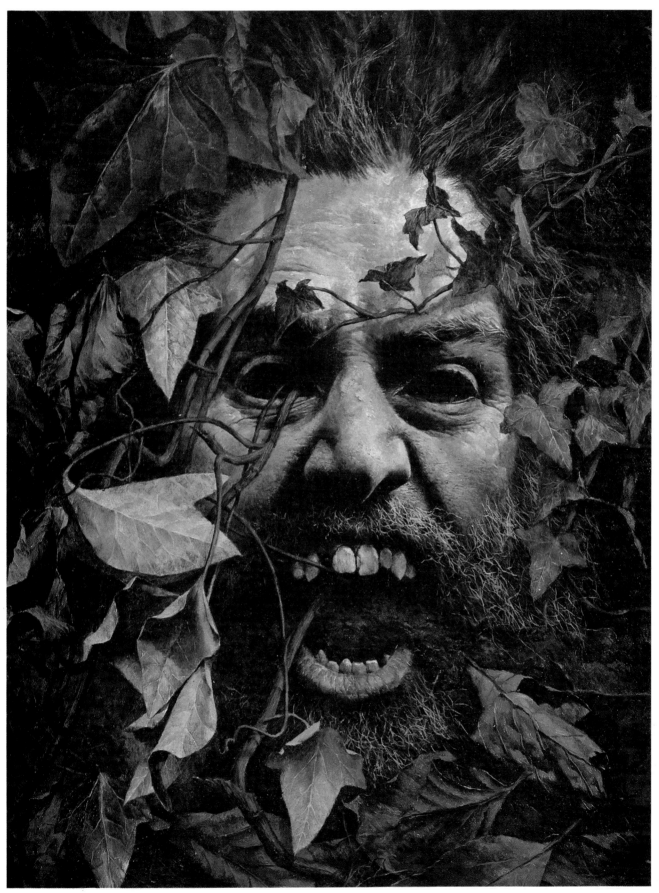

The Night Ghoul, Gordon Crabb.

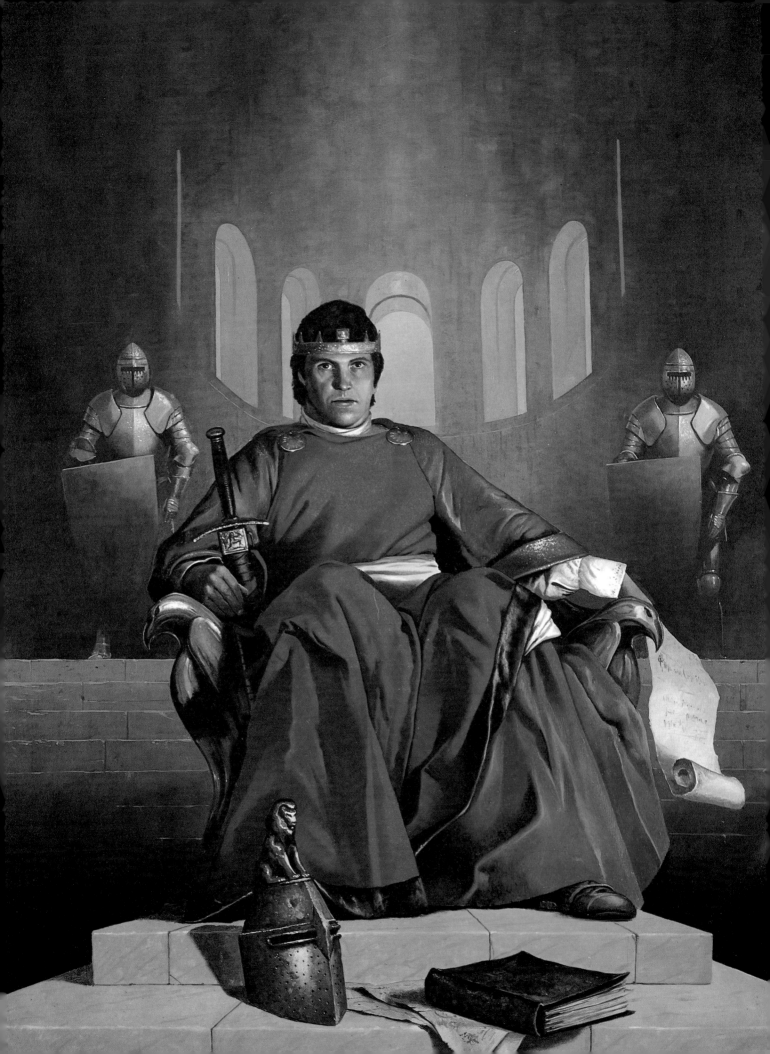

DREAMS
OF
CHIVALRY

In Irish legend Cuchulainn was later succeeded by Finn MacCumaill who is supposed to have lived in about the 3rd century AD and who is in many ways a parallel to Arthur in Britain. Finn founded the legendary Fiana, or Fenians, who roamed the country in bands guarding it against invaders from without and evildoers within. To be accepted into the Fiana involved a gruelling series of ordeals whereby initiates proved they could match Finn's own early exploits. Also, amongst numerous other vows, they renounced all property, rewards and family ties for so long as they remained with the Fenians. In summer they lived off the land while roaming in search of exploits, in winter they relied on the hospitality of the people they guarded.

With Finn the heroic ideal progresses from that of the lone hero battling against almost impossible odds, for glory as much as anything else, to one very close to the Chivalric ideal of the better known Arthurian tales. We also find a somewhat less serious approach to heroism, as shown by the occasion when a truculent Scottish giant came to test his strength against Finn. Instead of throwing his life away as a Barbaric hero would have felt obliged to do, Finn climbs into a cot and pretends to be his own baby son. Upon which the giant decides that perhaps he is not so keen to meet the father after all and goes home again.

The Bishop's Heir, Les Edwards.

71

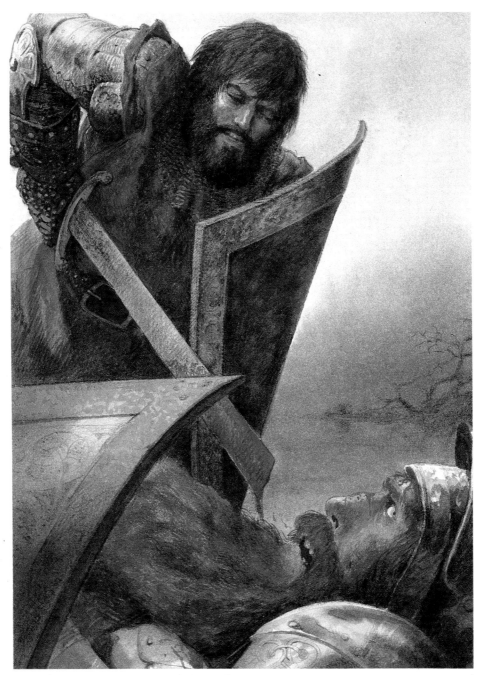

Knights, Sir Tristram, Julek Heller.

Such Celtic heroes lie at the root of the Arthurian cycle, though their codes and characters are considerably modified by the standards and expectations of Gothic France where many of the tales were first set down and elaborated. In particular the role of women is more that of Medieval Europe than of the age which the stories claim to be describing. To a lesser extent this is also true of the Irish tales because while in many ways they are truer to their originals, they do not fully reflect the

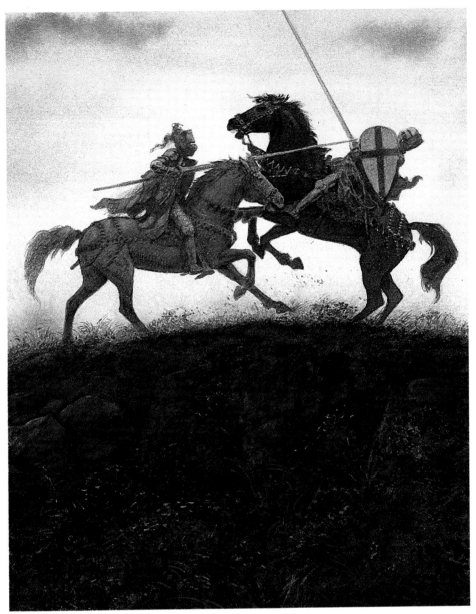

Knights, Sir Galahad, Julek Heller.

observation made by Caesar and other Romans that Celtic women often went to war with their menfolk and were as much to be feared in battle.

The world of the Chivalric hero is more complicated than the Barbaric one's because very often his main battles are against himself. It is perhaps significant that the two principal heroes of the Arthurian cycle are tragic figures—Arthur himself, haunted by the steady decline

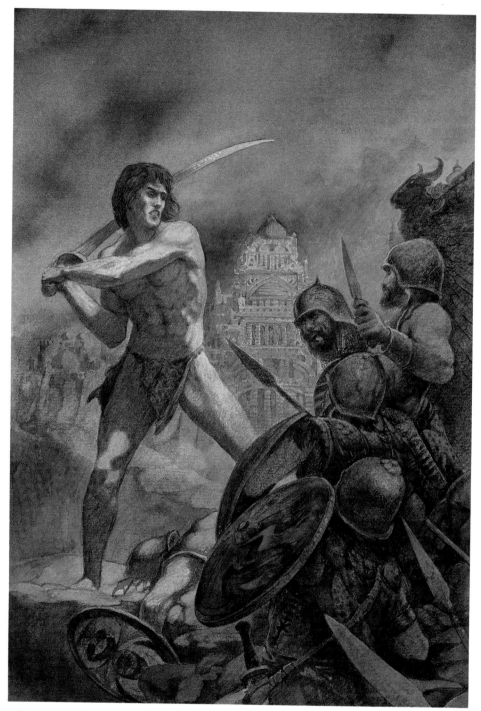

Flight of Opar, Julek Heller.

of his honour from the glory days of his youth, and Lancelot whose life is blighted by the impossibility of reconciling his love for Guenevere with loyalty to the King.

This fatal triangle was curiously re-enacted during the Arthurian revival of the 19th century in the Pre-Raphaelite circle (which was a more or less conscious re-creation of the Round Table) with William Morris in Arthur's seat, his wife Jane in Guenevere's and Dante

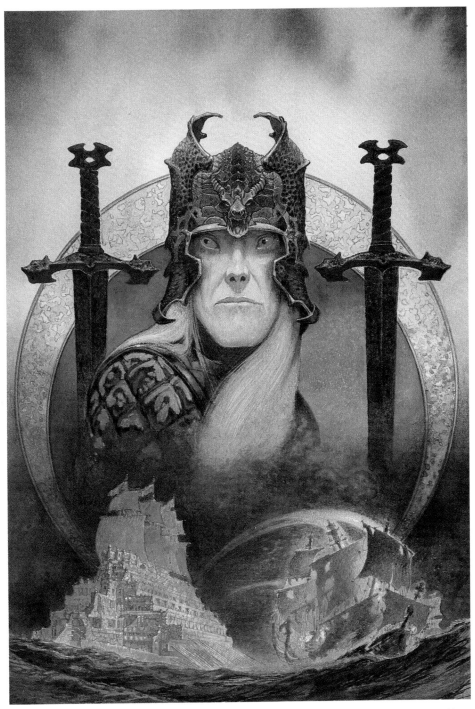

Elric of Melnibone, Julek Heller.

Gabriel Rossetti playing the part of Lancelot (though he thought of himself as Galahad). Sometimes when choosing our heroes we take on more than we know.

In modern Fantasy a hero who is torn between the Barbaric and Chivalric modes is Mervyn Peake's Titus Groan. A Barbarian at heart, he is unable to accept the role of Chivalric hero forced on him by circumstances and ends up a lost soul unable to find his place in

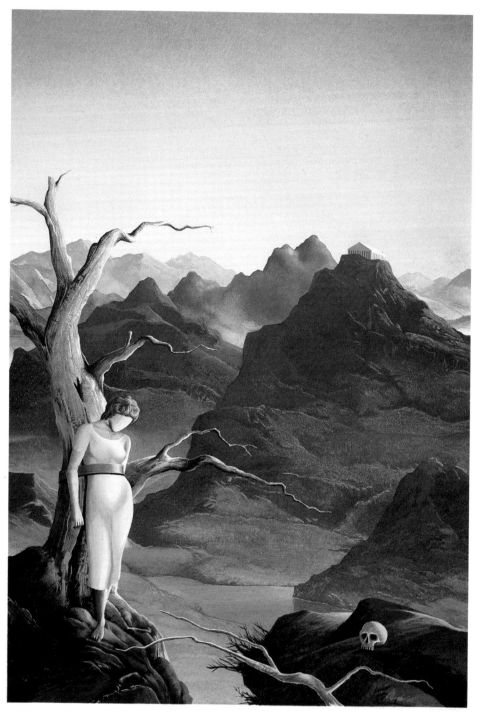

Till We Have Faces, Peter Goodfellow.

the world.

A similarly tortured hero (who is also torn between being a hero and the opposite) is Michael Moorcock's Elric, whose dilemma clearly touches a nerve in many Fantasy artists from the number of vivid interpretations of him which have appeared over the years.

Although in these cases it is taken to extremes, this position is not unusual for Chivalric heroes, reflecting as it does the perennial diffi-

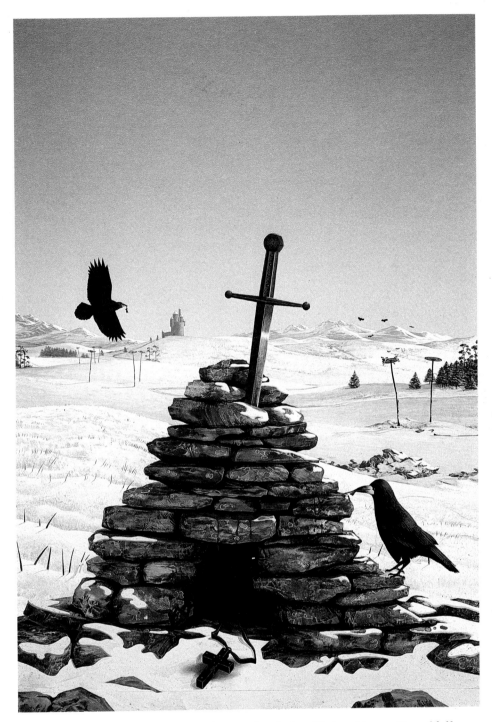

Orsinian Tales, Peter Goodfellow.

culty of creating a system of order which remains open to change and does not immediately begin to fossilise, of preventing the instruments by which anarchy is tamed becoming the instruments of suppression of all change.

Also it illustrates how, like the Barbarian, the Chivalric hero is partly in love with the order he displaces. He is at least partly a Barbarian at heart but becomes a hero by containing the impulse

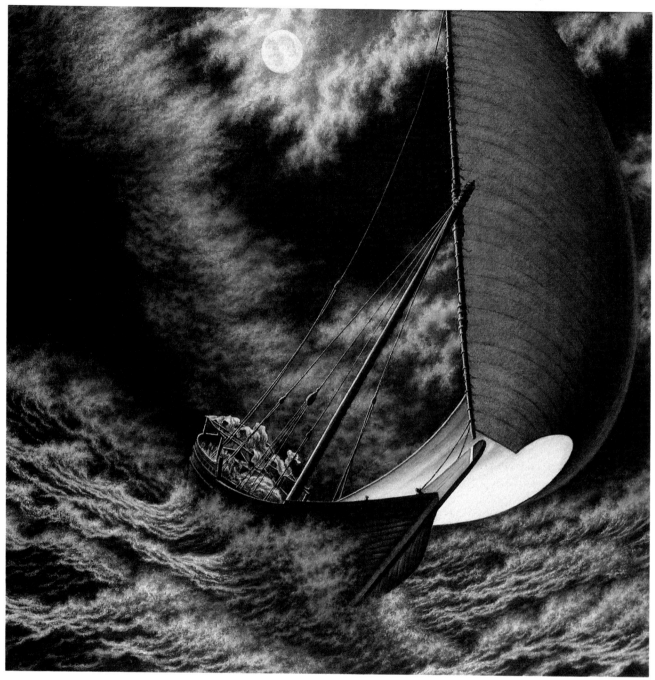

She, The Storm, Michael Embden.

within the mores of his era and thus winning the acclaim of his people, which shows the power the weak may sometimes exert over the strong. Although it is often assumed that it is heroes who shape the aspirations of their cultures, this is only partly true. The hero may well set an example to the rising generation and so help shape the future, but he is only raised to that position of influence by embodying the wishes of those who acclaim him (or her) in the first place.

William Morris, incidentally, in the course of his Herculean attempt

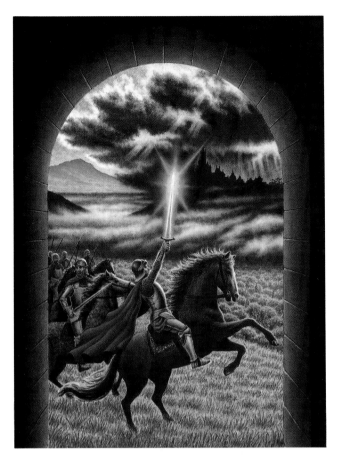

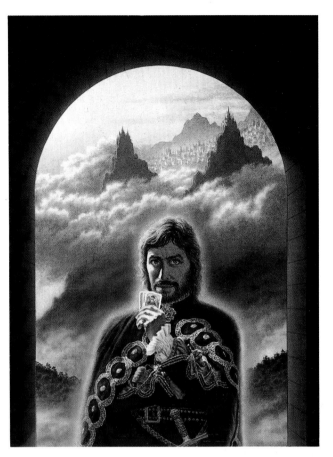

The Guns of Avalon, Michael Embden.

Nine Princesses of Amber, Michael Embden.

to initiate almost single-handedly a Medieval Renaissance embracing the arts, crafts and politics of Britain, wrote several Fantasy epics and at least one Science Fiction novel set in the 21st century. His *News From Nowhere* is a Utopian vision of the world (or Europe at least) as it would be if all his dreams were fulfilled. At the time it caused a great stir and fired the imagination of many political idealists, but his view of Europe after Socialist revolution in the 20th century has a rather wistful ring now. Especially since there is reason to believe it to be not

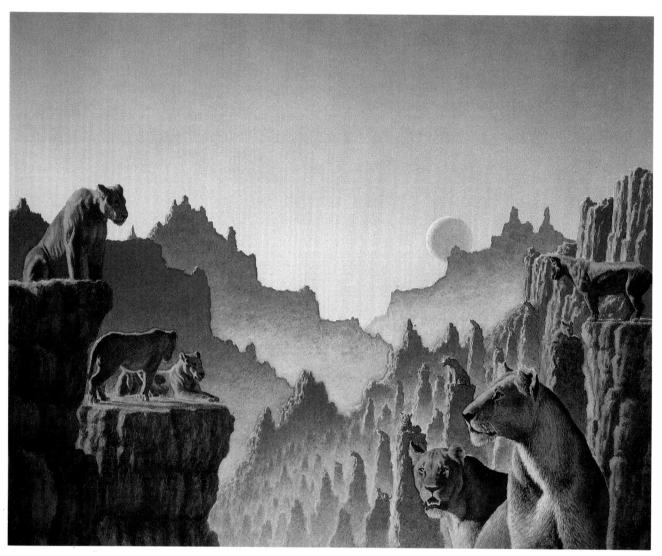

Masters of Everon, Michael Embden.

very different from Marx's own vision, as they moved in the same political circles.

The conjuring of Utopias (or Dystopias as the case may be) is one of Science Fiction's most useful functions, and such visions need not be prophetically accurate in order to make their point. 1984 has come and gone (marked by probably fewer dating errors at the beginning and more sighs of relief at the end than any other year this century) without George Orwell's bleak prediction having quite materialised,

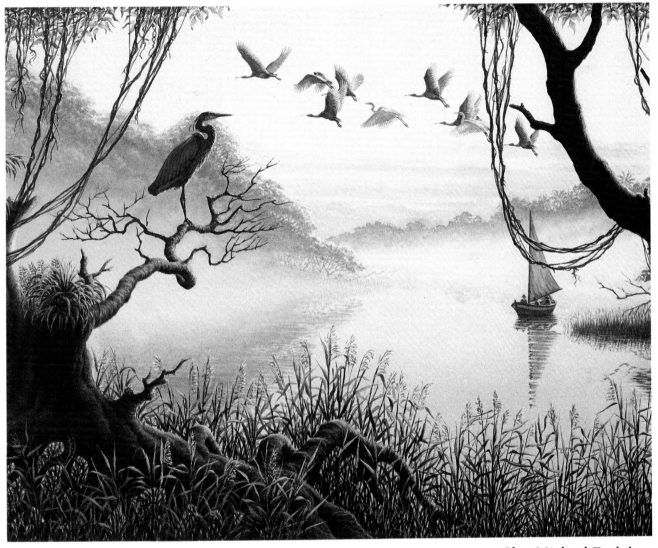

She, Michael Embden.

but it is arguable that his book did more than any other to prevent itself being fulfilled. It is the perils we don't forsee that are most likely to snare us.

Also, on a technical level Science Fiction is more free to explore new ideas than Science itself, being untrammelled by the need to actually make its proposals work. Jules Verne's proposed method for launching people into space by means of a giant cannon may in itself have been pretty laughable but it almost certainly set a few scientific and

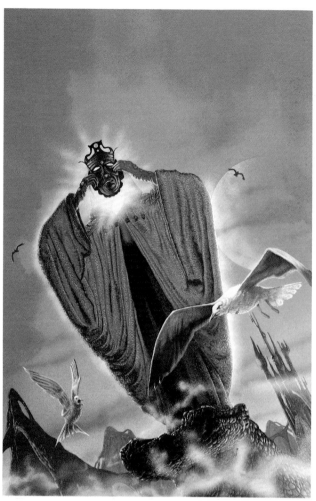

The Awakening, Terry Oakes.

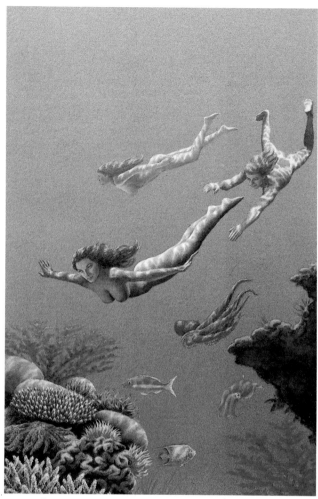

The Merman's Children, Michael Embden.

engineering brains ticking and, even if only on a subconscious level, must have played some part in making space flight a reality.

Nor is the capacity of his idea to provoke thought yet exhausted since its basic thesis, that a spaceship should be projected from the ground instead of having to carry its fuel on board (and hence more fuel to lift that fuel and so on) is currently being re-examined. The end result is more likely to be some kind of giant slingshot than a cannon but the principle is the same.

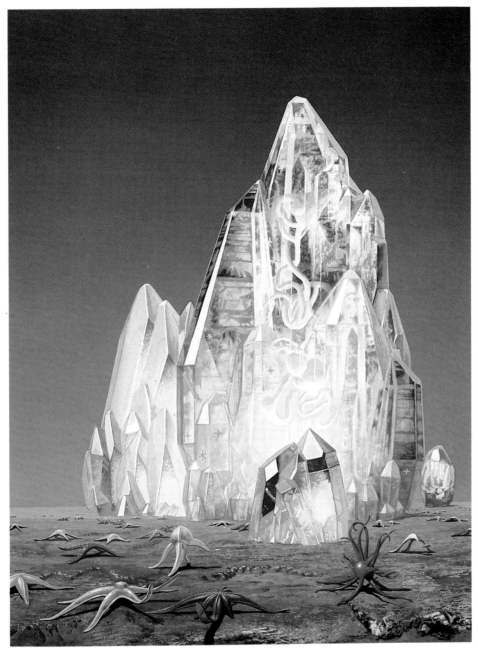

Crystaline Beings, Richard Clifton-Dey.

The idea of space travel may appeal to some simply because it offers a new and wild frontier where anything may happen, but it also has a strong Chivalric appeal. Possibly the most famous space hero in British comics is still Dan Dare, who fired the imagination of a whole generation of schoolboys in the 1950s and early 1960s. Dan Dare was a Lancelot type through and through, apart from having a negligible love life.

It is often forgotten now that there was a significant, though argu-

83

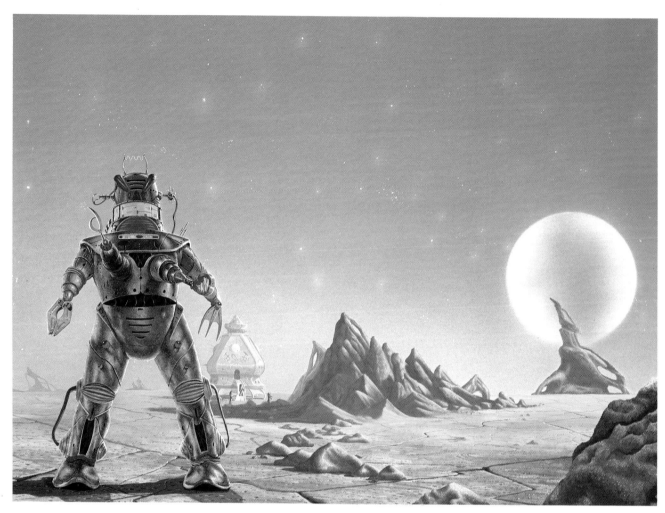

Across a Billion Years, Terry Oakes.

ably misguided, element of Chivalry among the European colonists scattered across the globe until recently. In the light of history one only hopes it will be more apparent to any aliens we encounter than it was to most Africans and Asians who came under European rule. That is, if they do not turn out to be more powerful and come to colonise us.

In Science Fiction art the Chivalric aspect of space exploration is often conjured in scenes containing no visible humans at all, the mood often being conveyed by the sculptural language of spacecraft and

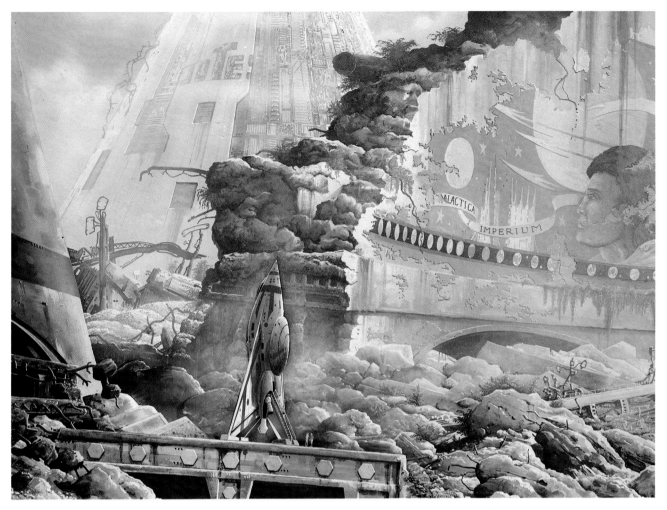

The Thousand Years War, Bob Layzell.

other human artefacts. To appreciate these, of course, one needs an instinct for the innate beauty of technology, which is perhaps why they do not appeal to everyone. In others the mood is evoked by balancing artefacts against awesome land- or skyscapes. In such pictures it is not space's immediate perils that are stressed but the immensity of its challenge.

Plato once proposed that all possible inventions already exist on a certain plane accessible to the imagination. The example commonly

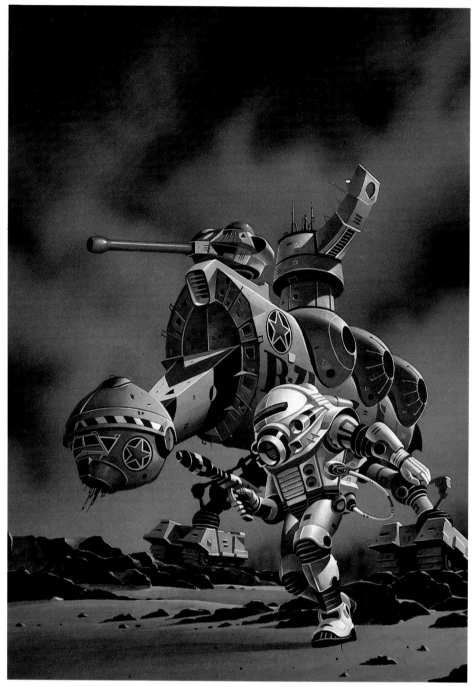

The Third Machine Age, Robin Hidden.

quoted is of a table. On this imaginative plane the idea of a table existed long before one was ever made in the world. It did not have four legs, or three, or any number of legs at all. Nor was it any particular shape or size. Rather, the idea was simply that of a surface raised off the ground for things to be put on. Once someone discovered the Platonic idea of a table, the myriad designs which have since filled the world became possible.

In Jules Verne's case the Platonic idea he presented in his tale was

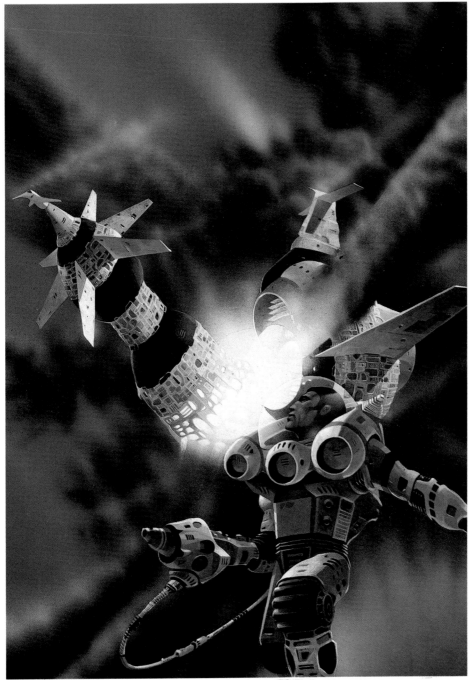

Angel of Death, Robin Hidden.

that of space travel. Knowing no better, he could only present it in the technical language available to him, which is why it now seems rather quaint; but the importance of his story is that it pointed readers' minds towards the unshaped idea which lay behind it.

It is well known that the Romans had both the knowledge and technical capacity to build steam locomotives but they didn't because it never occurred to any of them to try. One function of Science Fiction, then, is to fish these Platonic ideas out of the ether. It may also

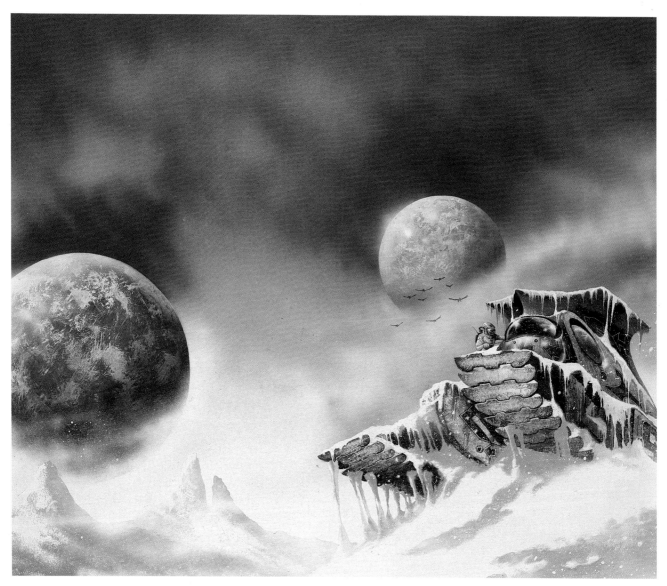

Postmarked The Stars, Tony Roberts.

fish out a lot of Platonic red herrings but that is by the way. Science Fiction's virtue is that it provides a way of exercising the scientific imagination.

Plato is of course also responsible for writing one of the first consciously contrived Fantasies—his account of Atlantis in *Timaeus and Critias*. Although quite possibly based on an existent legend which may or may not have contained some truth, it is clear from internal evidence that any original material was freely shaped to suit his

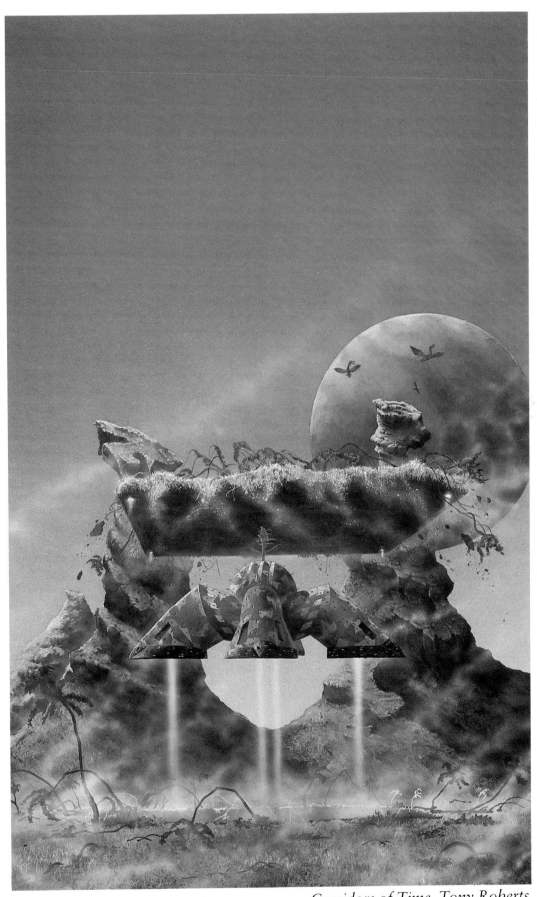

Corridors of Time, Tony Roberts.

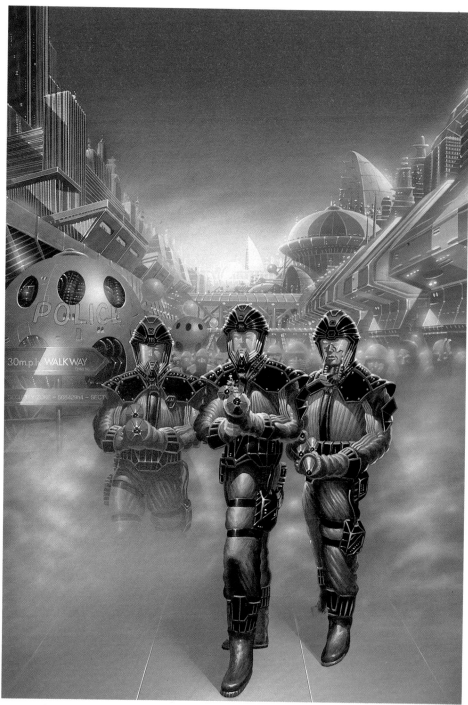

War of The Computers, Alan Craddock.

own ends. But like a modern novelist he presents his account as if it were completely factual and able to be supported by other written and oral evidence.

What ancient legends have in common with modern Fantasy and Science Fiction is the projecting of inner dreams onto a matrix capable of giving them an illusion of reality. Where they differ is the degree to which their audience believes that reality. Primitive audiences generally accept their legends as describing concrete fact but the

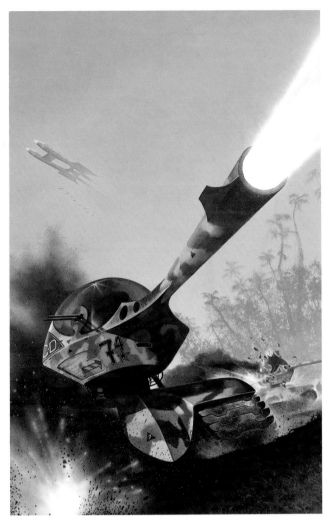

The Mercenary, Tony Roberts.

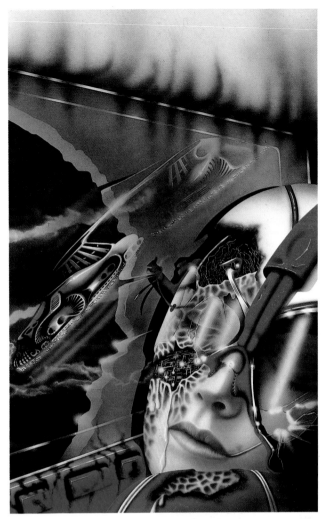

Battle by Proxy, Alan Daniels.

process of civilisation teaches people to suspend their belief to some degree in order to enter the spirit of a tale.

Of course, the less we have to do this the better. When simply looking for entertainment we may happily suspend disbelief completely for a while, but when a fable begins to strike deeper chords within us it helps if we can imagine that the story at least *could* be true.

This is the great attraction of space—so little is known about it that almost anything becomes possible. The exploration of the Solar

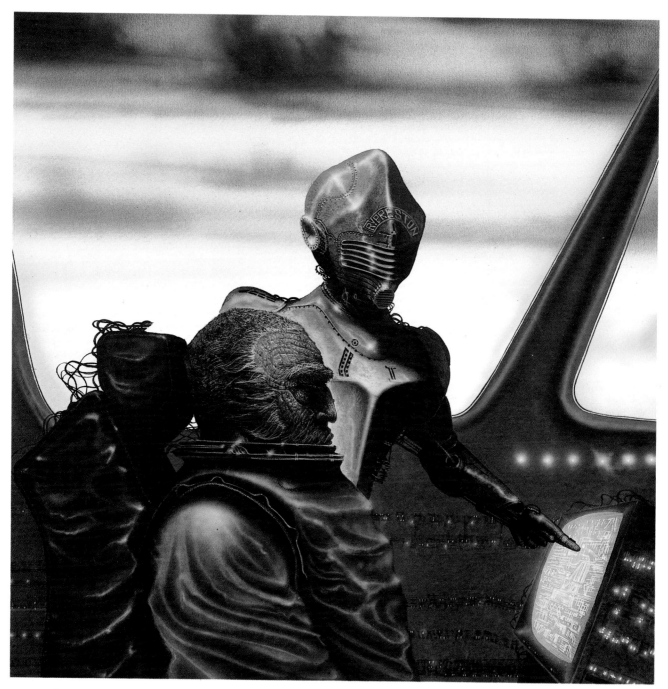

Best of Isaac Asimov, Tony Roberts.

System may have undermined the credibility of hundreds of tales which populated it with creatures not so very different from those on Earth, but so many billions of stars and planets remain that statistically speaking almost anything still remains possible.

At the turn of the century Rider Haggard used unexplored Africa and Asia much as Science Fiction writers now use space for his

Mortal Gods, Jim Burns.

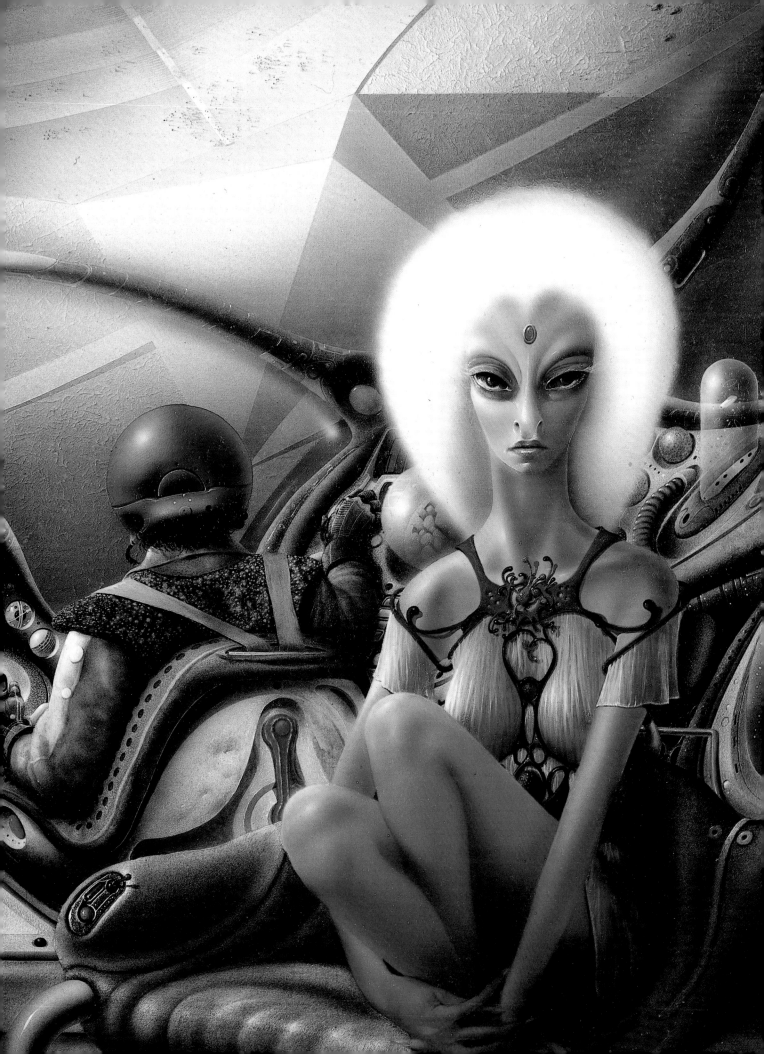

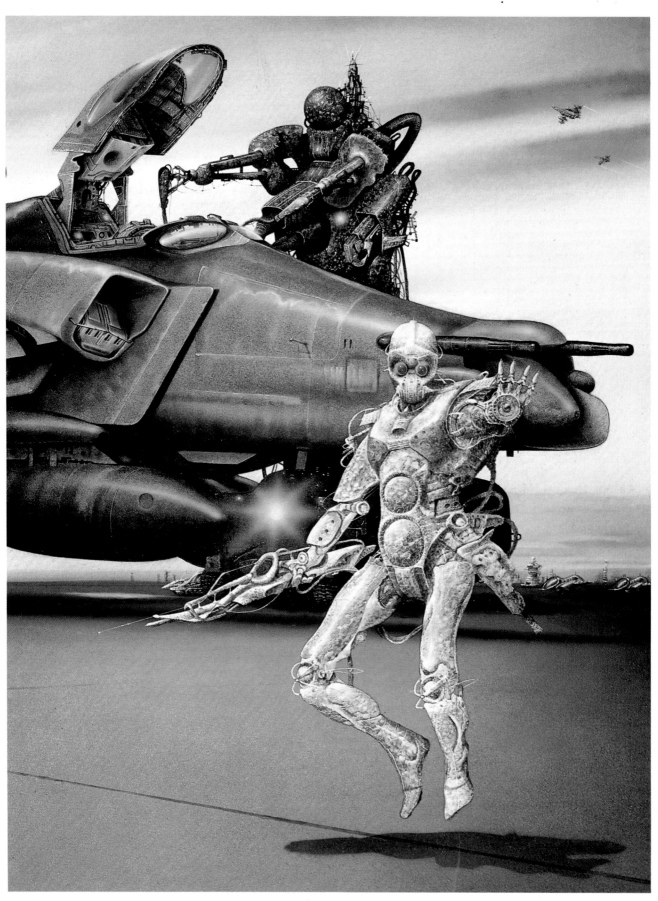

Mechanismo, Jim Burns.

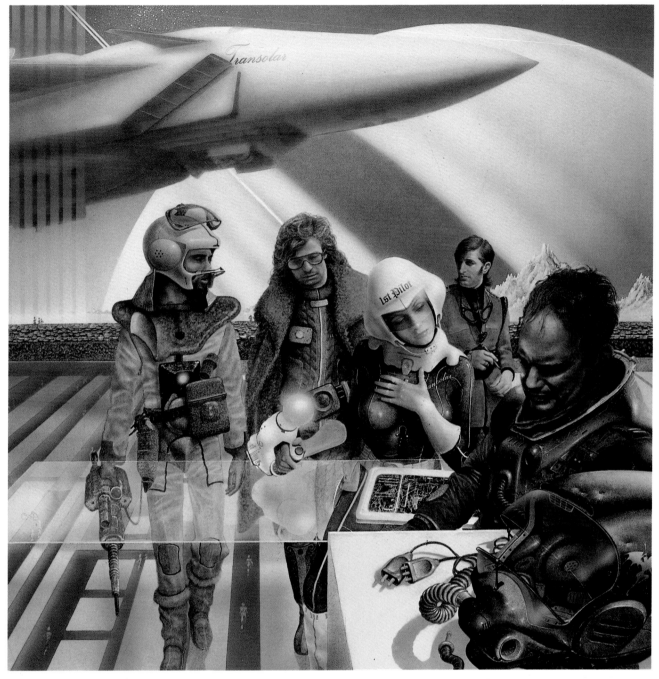

Spaceport, Jim Burns.

fantasies about Allan Quartermain and She, and it says much for the power of his writing that his main works are still in print despite those continents having been laid bare to European eyes. At the time of publication they were widely accepted as true accounts and several adventurers even set off to find King Solomon's Mines for themselves, following the unfortunately plausible topographical clues given in that book.

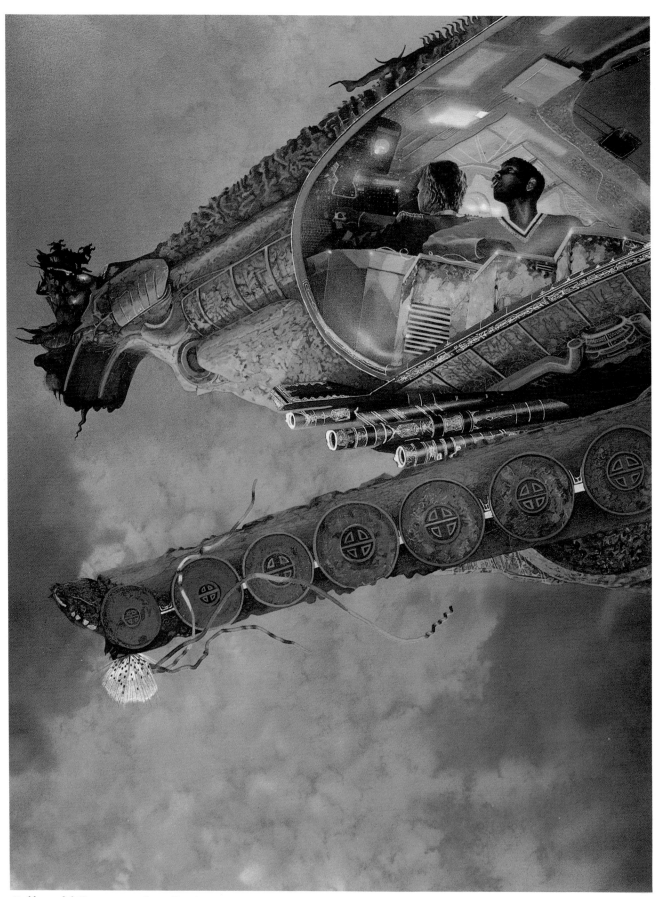

Offworld Baroque, Ian Craig.

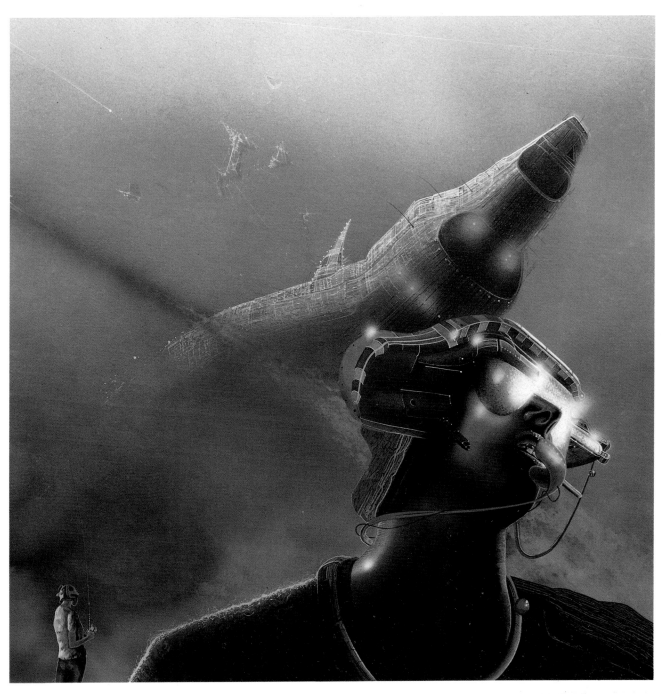

Wargames, Ian Craig.

A more recent writer who compels a similar level of belief is Doris Lessing in her remarkable foray into Science Fiction—the *Canopus in Argos: Archives* series—an astonishing achievement which dissolves the light years between the stars and makes contact with other civilisations seem not only possible but likely. It is rumoured that when Lessing first approached Science Fiction publishers with this work

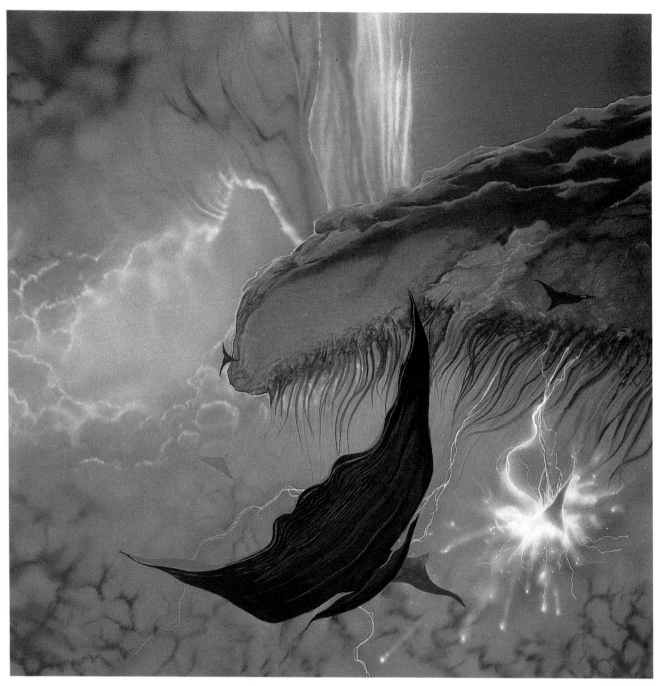

Mantas Attacking Medusa, Ian Craig.

under a pseudonym she was universally rejected. Whether or not this is true, her books do stand a little apart from the mainstream of the genre; not only because of their serious intent and depth of character but for the small interest they take in space hardware.

Arthur C. Clarke's very different though equally intelligent approach is well exampled by his *Rendezvous with Rama* in which, by previous

98

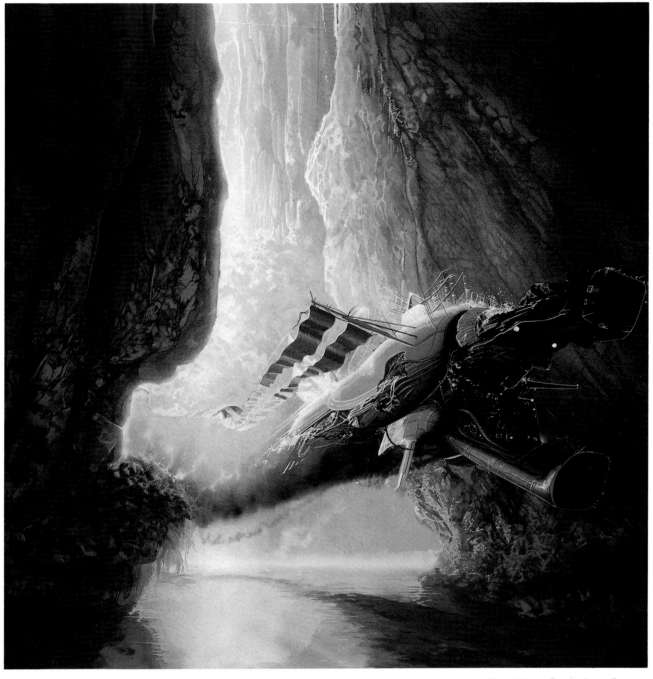

Down But Not Out, Ian Craig.

standards anyway, very little happens but the story grips the attention by its sheer credibility. While Lessing leaps beyond the technicalities of space travel by considering a civilisation in which spaceships are about as useful for interstellar travel as dug-out canoes, Clarke perches on the precipice of our technology and considers what might happen next.

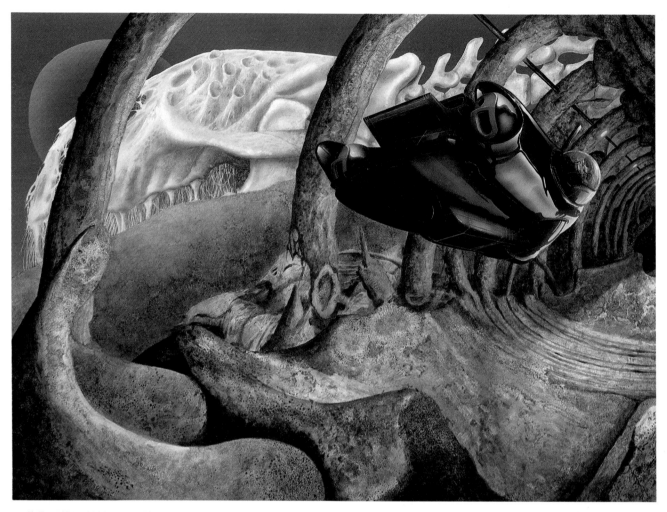

The Hollow Skull of Behemoth, Jim Burns.

Most Fantasy and Science Fiction is less serious in its intent, however, and there is nothing wrong in this. As with the Medieval Arthurian tales their aim is not just to examine and reflect current dilemmas and preoccupations (which is usually done unconsciously anyway) but to entertain. In fact, one may go further and say that, as with any other form of fiction, the prime purpose is entertainment and any didactic function is secondary.

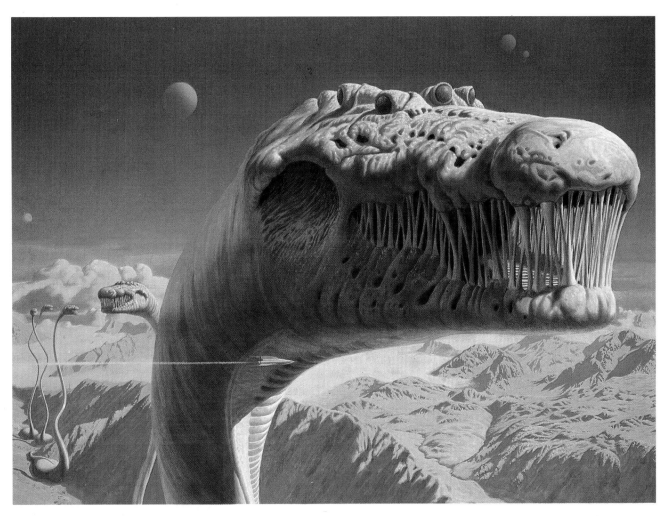

Behemoth's World, Richard Clifton-Dey.

In this sense fiction can work in the same way as dreams. In most powerful fiction there is an underlying message which can be uncovered by those who wish to do so, but authors who spell it out too plainly are in danger of losing their audience since people generally resent being preached at in their own time. Any message concealed in fiction works only if people want to know what it is.

Fantasy and Science Fiction in general appeal to similar readers

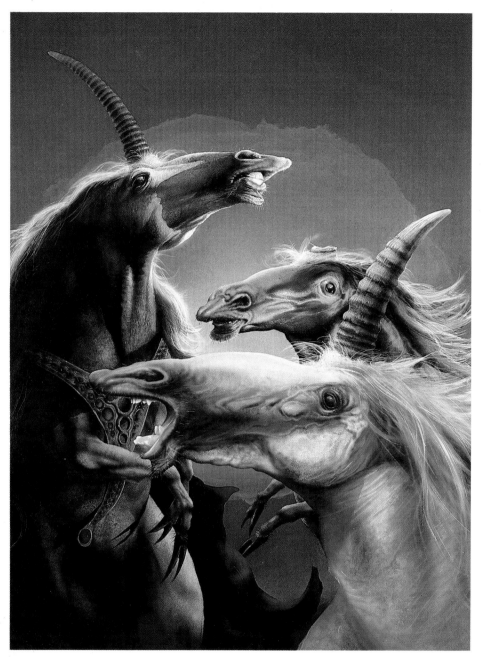

Unicorns, Jim Burns.

although Fantasy usually projects itself backwards to either a Barbaric or pseudo-Medieval setting. This can be misleading, as for example with Plato's Atlantis. He claimed to be describing a near perfect State which had been lost in the mists of time but was in fact describing his own vision of an ideal future one.

As for the large number of Medieval settings in Fantasy, it is possible they arise from a lurking suspicion that when the bright light

Lifeburst, Jim Burns.

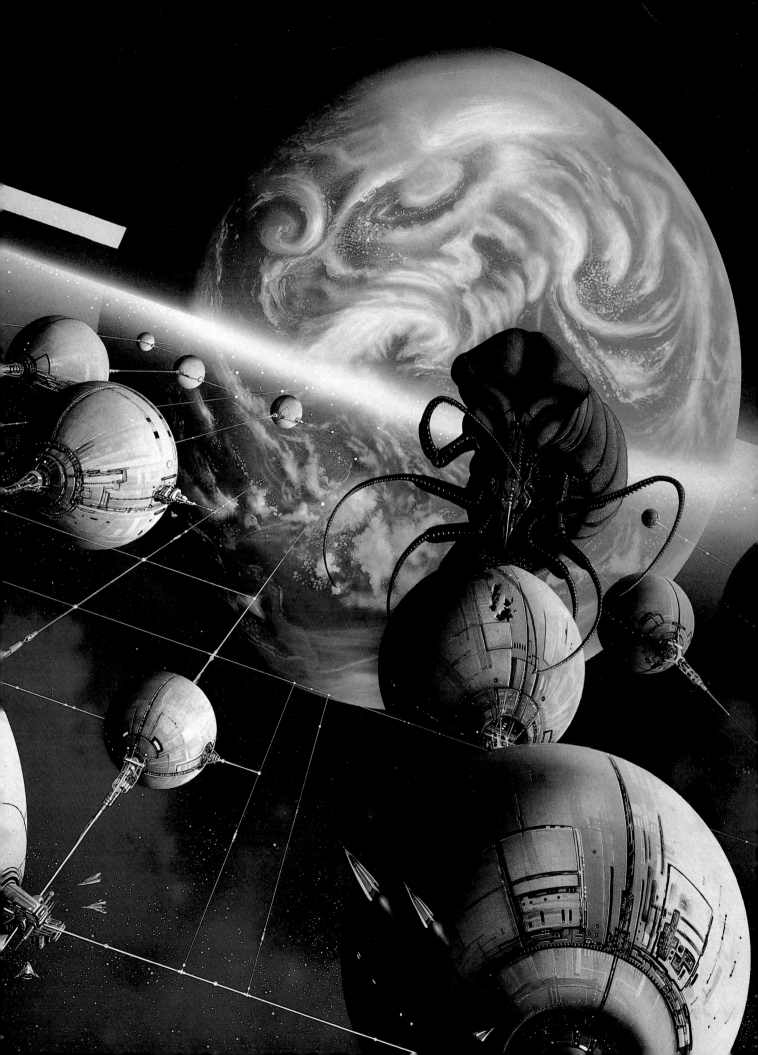

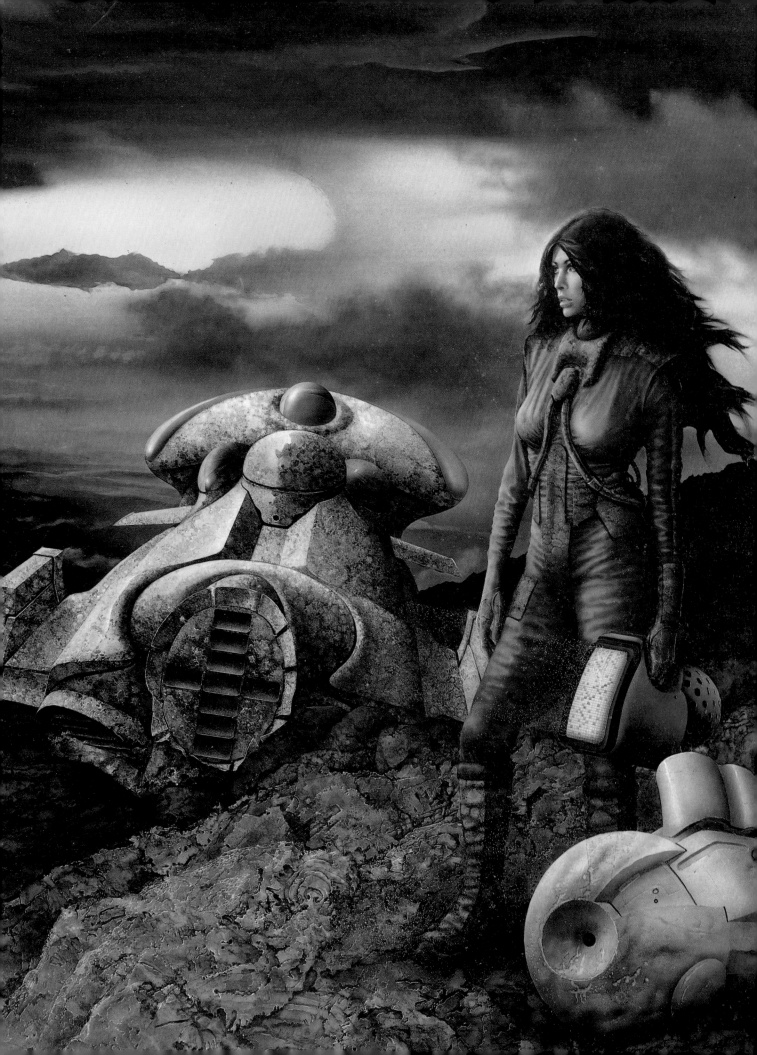

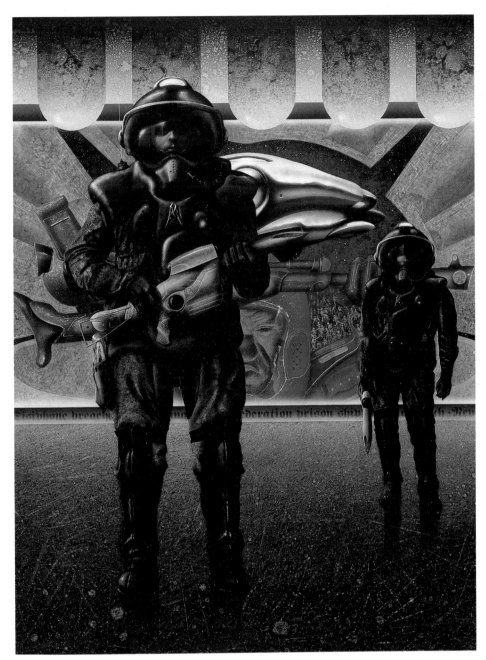

Mural, Jim Burns.

of the European Renaissance dispelled the superstitious shadows of the previous age, it dispelled a few other things as well. The suspicion that, to change the metaphor, a few babies may have been thrown out with the bathwater.

Of course, many would argue that the yearning for such idealised worlds is akin to the yearning for lost childhood. They may be right, but not necessarily so. Few forward steps have been taken in history

Brother to Demons, Brother to Gods, Jim Burns.

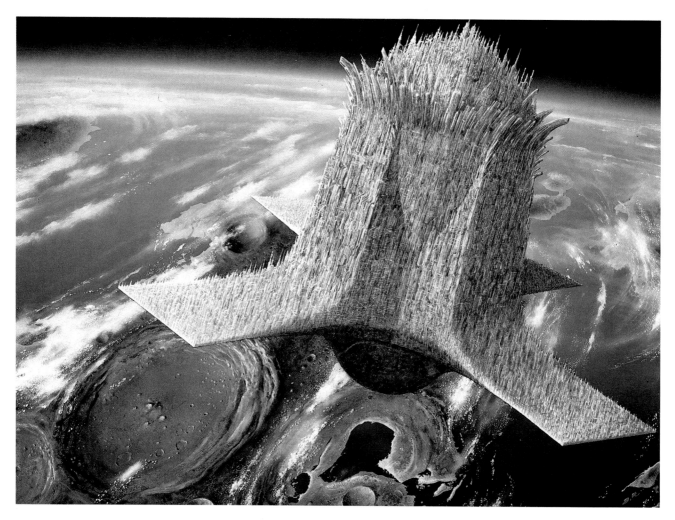

Refuge, Jim Burns.

without at least half a step back. People in the Middle Ages may have believed many things which now seem strange to us, but they were no less intelligent than humans are now. Any one of us transported back to that time at birth would grow up accepting the common views of society to the same extent that we do now, and they would appear to be founded just as solidly on proven fact.

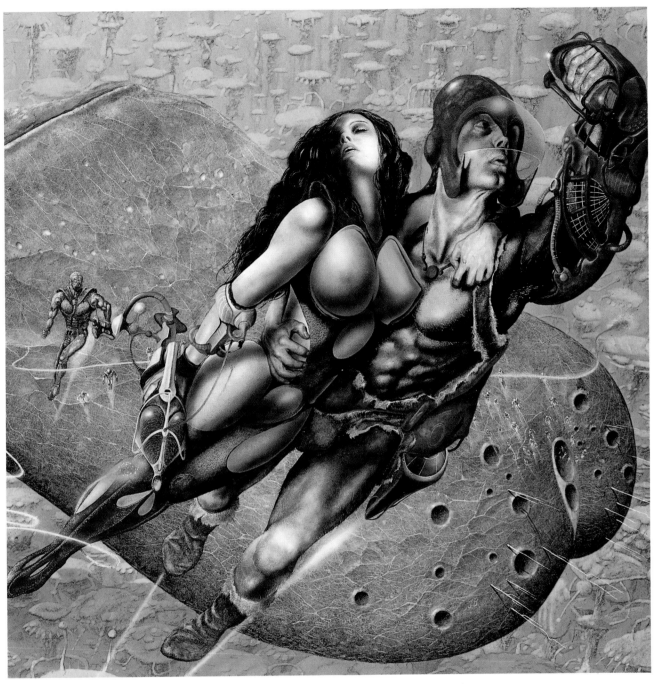

Great Balls of Fire, Jim Burns.

To return to our earlier point, the proof that there are no dragons in the world has not completely dispelled the idea that they should, or might, exist somewhere. The reason for this is that, at the very least, dragons, sirens and the rest have a symbolic value—they mean something to the imagination. Ancient myths conveyed wisdom to successive generations by couching it in symbolic terms. People did not realise

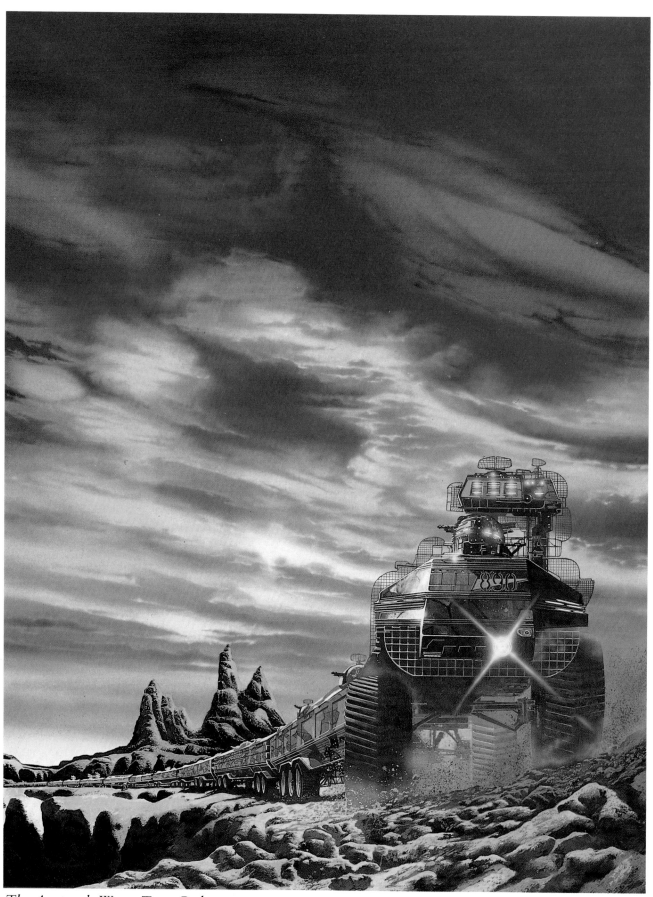

The Amtrack Wars, Tony Roberts.

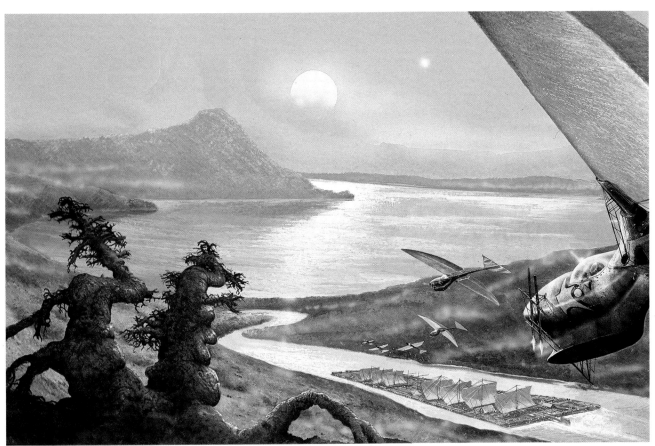

Mesklin 3, Tony Roberts.

this because they believed the myths to be describing concrete fact, but they imbibed the wisdom anyway. The best of modern myths do the same because on a subconscious level the symbols they employ have the same meaning as ever. Wizards and dragons and giants may have been banished from the world but they have not been banished from the human imagination. Which brings us back to King Arthur.

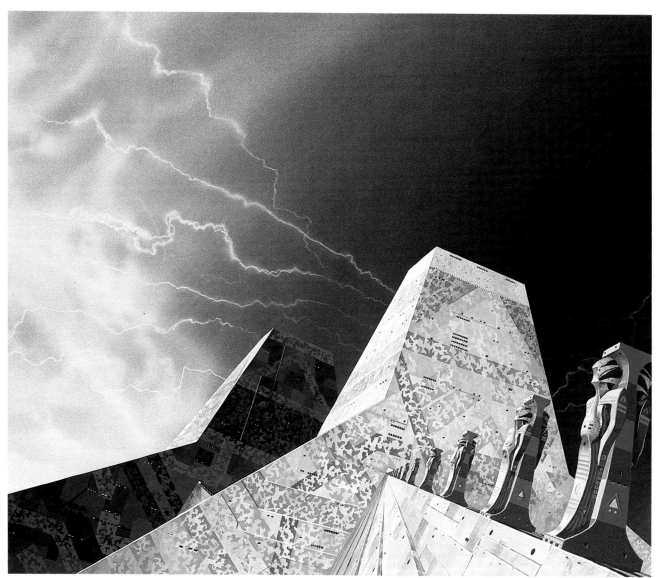

Sleepers of Mars, Colin Hay.

It is perhaps significant that the most famous collation of Arthurian tales, by Malory, has come to be known as the Death of Arthur, not the Victory. Shattering the barbarian invasion and establishing the Kingdom of Logres is covered quite briefly in both Malory's book and the cycle generally. Most of the tales concern the adventures of Lancelot and other Chivalric knights within the context of that domain and against the background of its gradual decline. Part of the

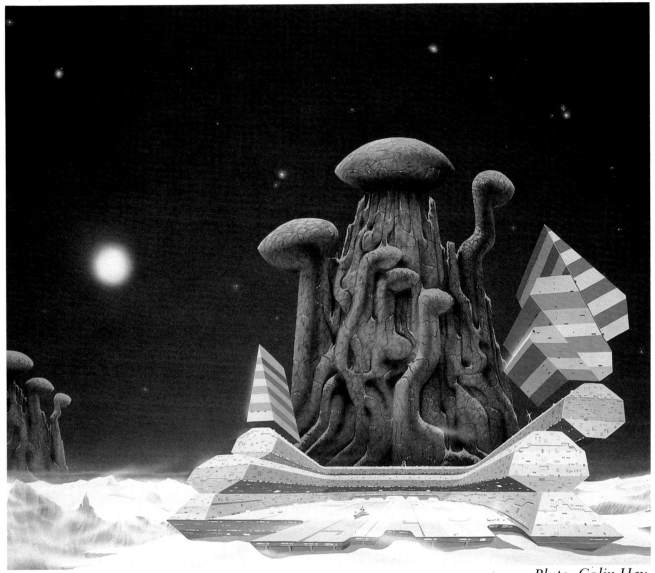

Pluto, Colin Hay.

cycle's continuing appeal must be due to its reflection of this universal and constantly recurring experience of gradually falling from a state of grace.

The legend has been somewhat debased by numerous treacly 20th century renderings but its power to still provoke real inspiration is well shown by Mary Stewart's powerful *Merlin* trilogy. A little-known fact which is also worth mentioning is that it was the lifelong dream of

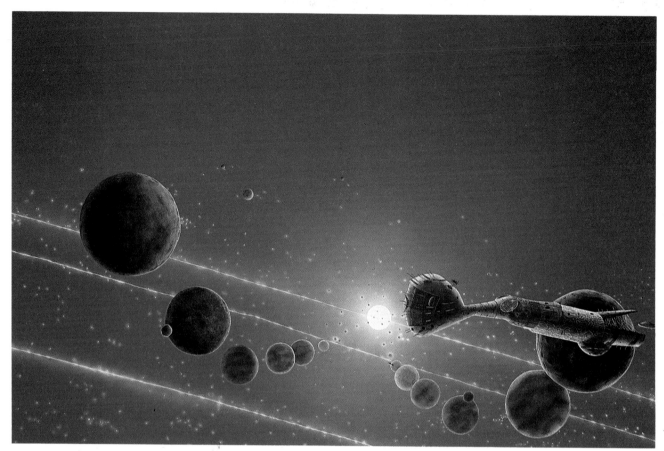

Before the Golden Age Four, Tony Roberts.

John Steinbeck (*Grapes of Wrath* etc.) to bring Malory's book to life again for modern readers unable to handle the somewhat indigestible prose of the original. Unfortunately the project was only partially realised despite years of intense work.

The bulk of the Arthurian knights' adventures deal with the problems of living up to the Chivalric ideal and imposing it on the pockets of villainy scattered about the tangled forests of Logres; but with the

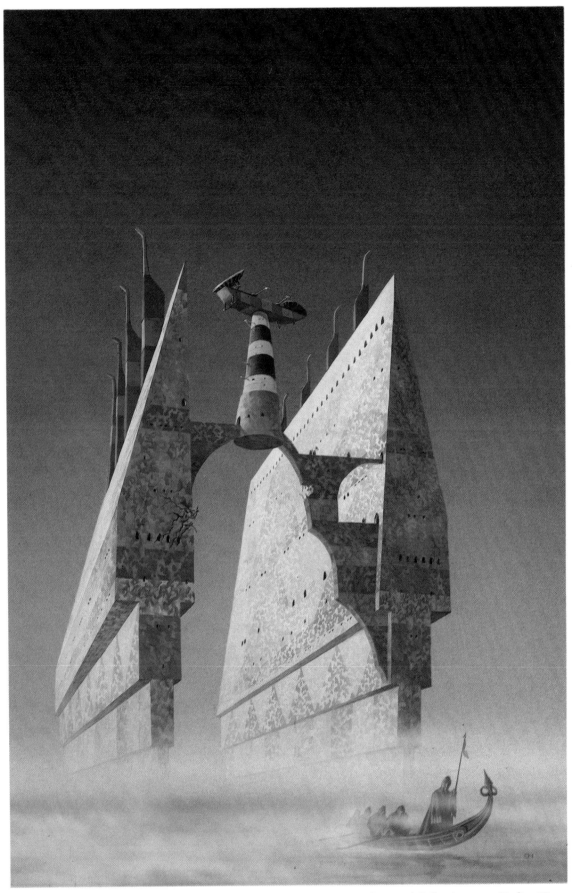

Enchanted Pilgrimage, Colin Hay.

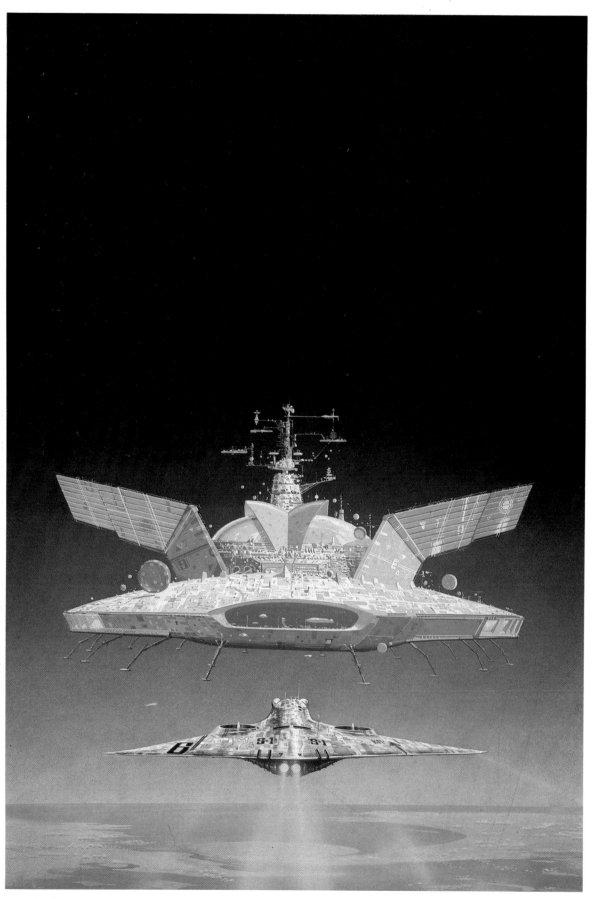

Again Dangerous Visions, Angus McKie.

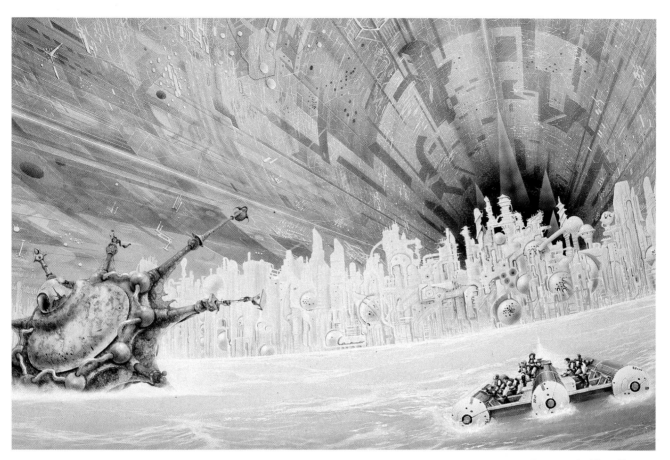

Rama 3, Jim Burns.

appearance of the Holy Grail all this suddenly changes and the values of Chivalry itself are called into question.

This is not altogether surprising since, despite the more flexible and humane code of honour, knights still spend a fair amount of time killing each other for no good reason. There are other failings readily apparent to modern minds but what the Grail quest proposes is not simply a further refinement of the heroic code but a complete transformation of it.

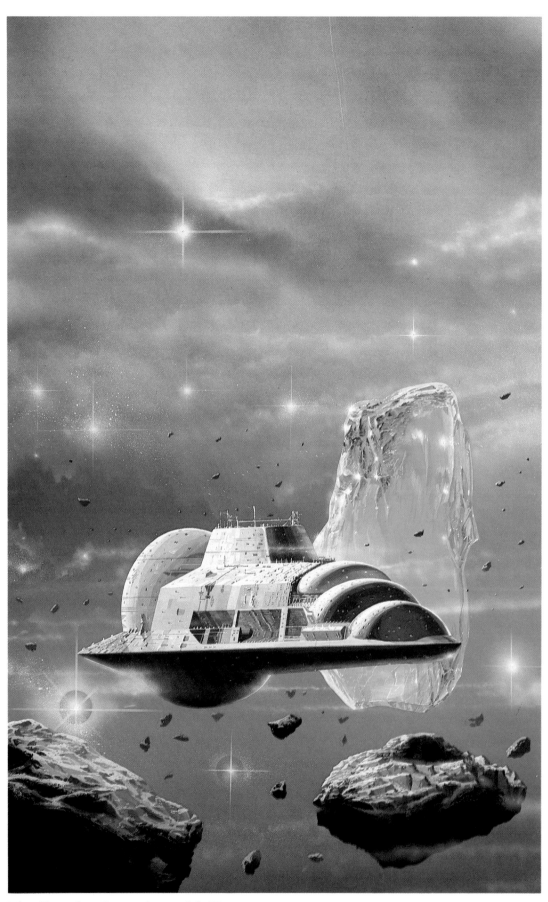

The Ship that Sang, Angus McKie.

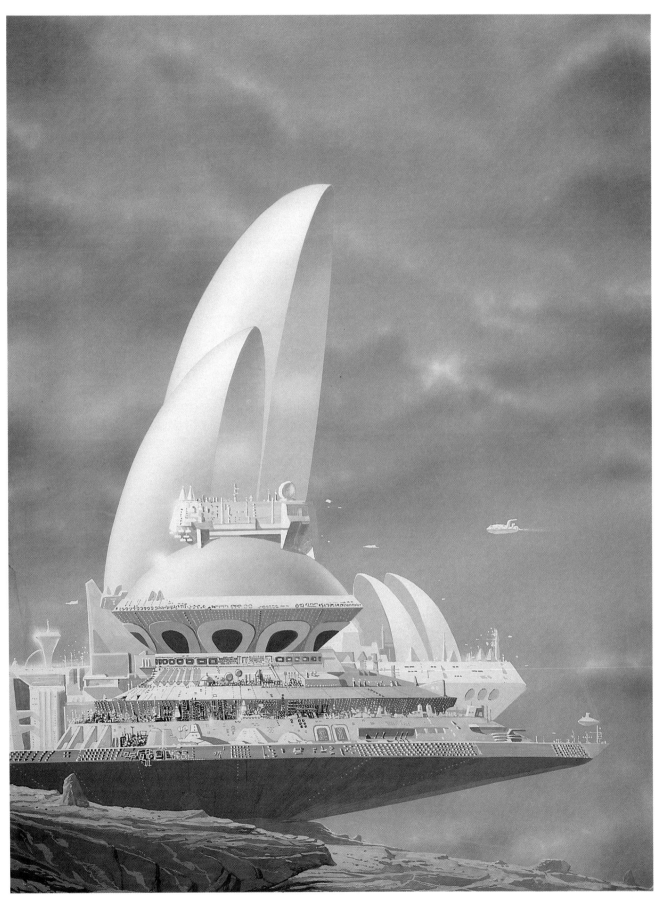

Restoree, Angus McKie.

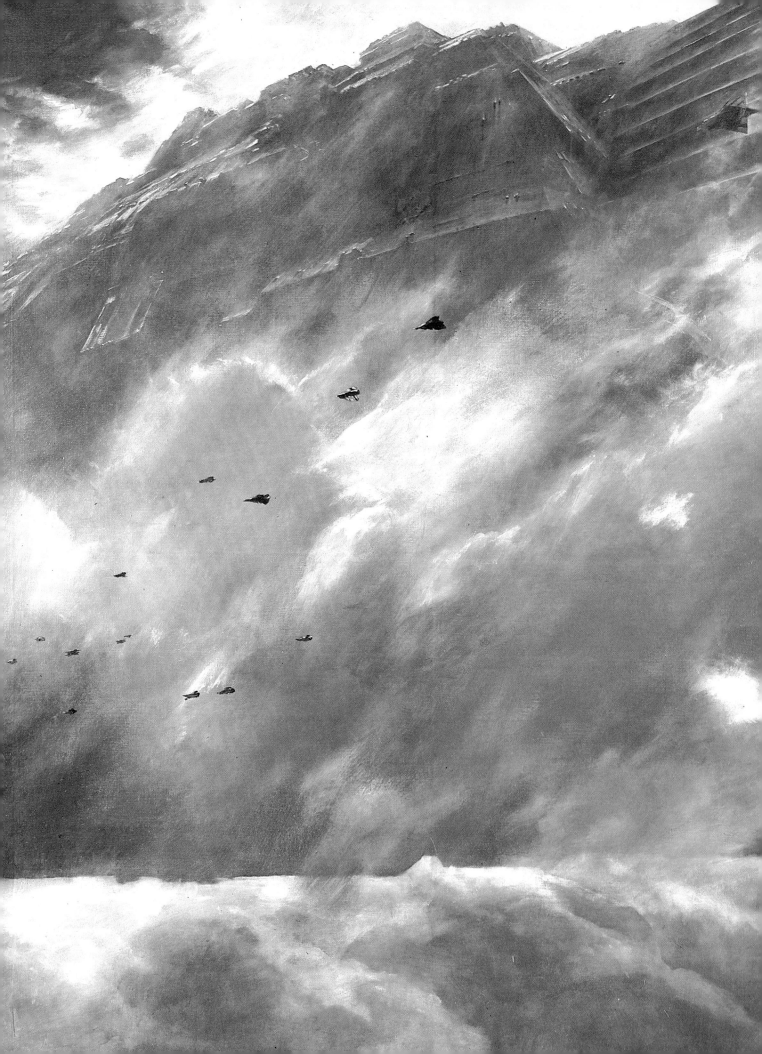

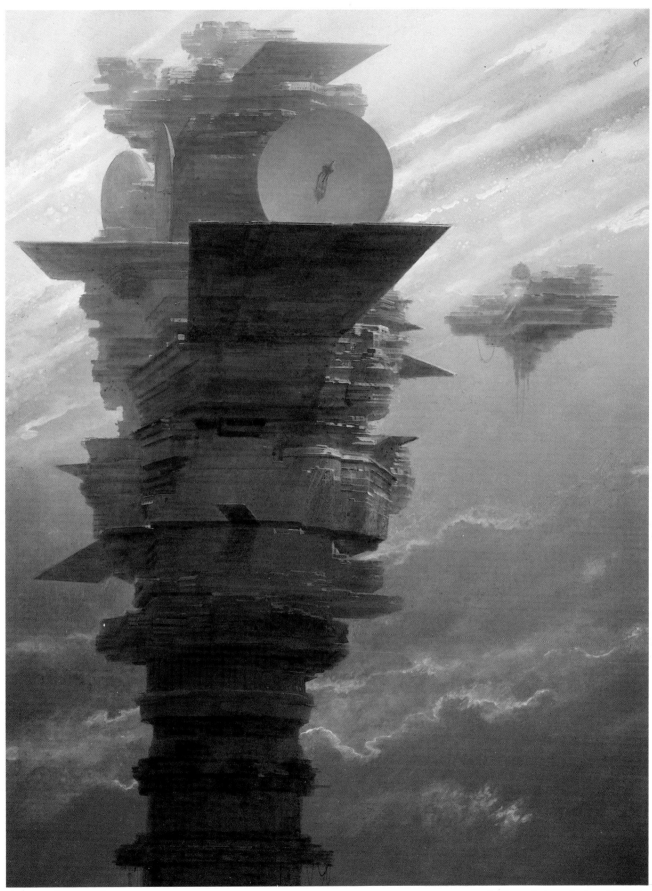

Triptych 2, John Harris. *Microdrive, John Harris.*

119

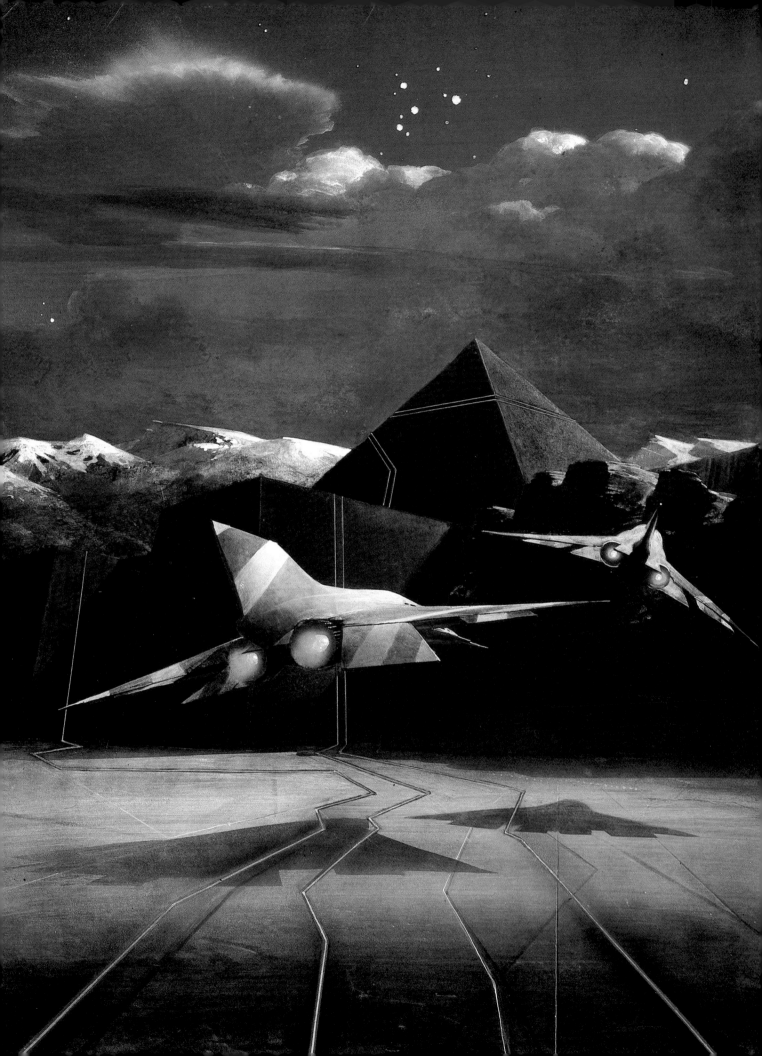

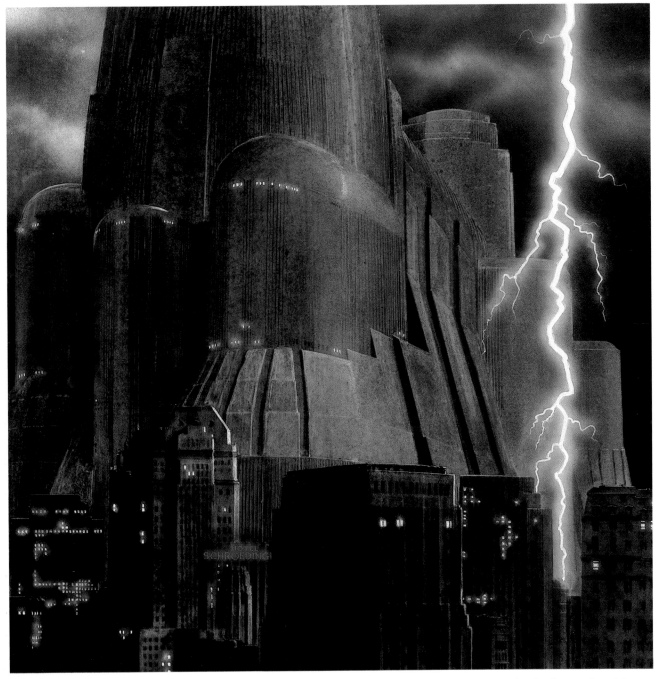

Cathedral 2, John Harris.

The timing of the Grail's sudden appearance to the assembled knights of the Round Table is no accident. It is a common ancient belief that a realm's fortunes are reflected in the health and well-being of its monarch. In many early cultures, including Celtic ones, this resulted in the ritual killing of monarchs when they showed signs of infirmity.

Although in the time of even the historical Arthur this custom

The Man Who Ate The World, John Harris.

121

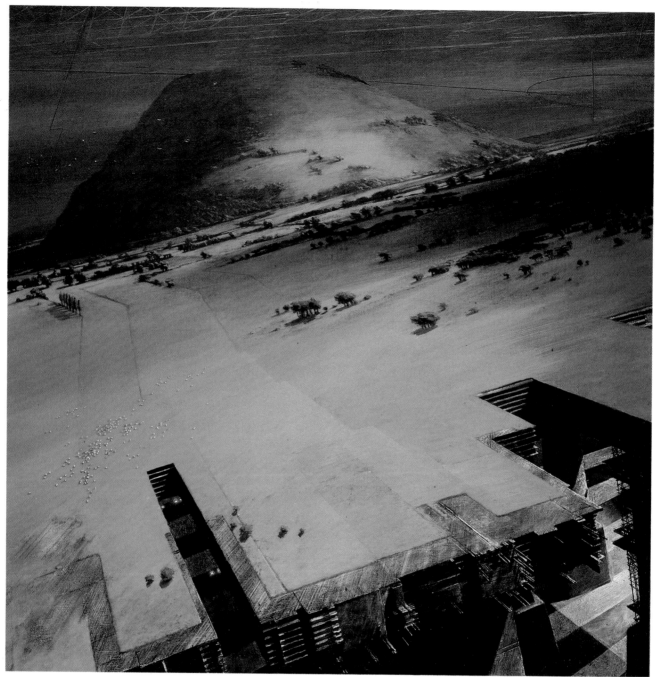

Sinclair Mural, John Harris.

would have given way to some symbolic substitute, the identity between him and his realm remains in the Medieval tales. The decline of the Kingdom from the glory and high hopes of its foundation is more fully reflected in the decline of his honour than any other evidence in the tales.

The Grail appears at a point when Arthur, like many another person before and since at his stage of life, is beginning to wonder what the

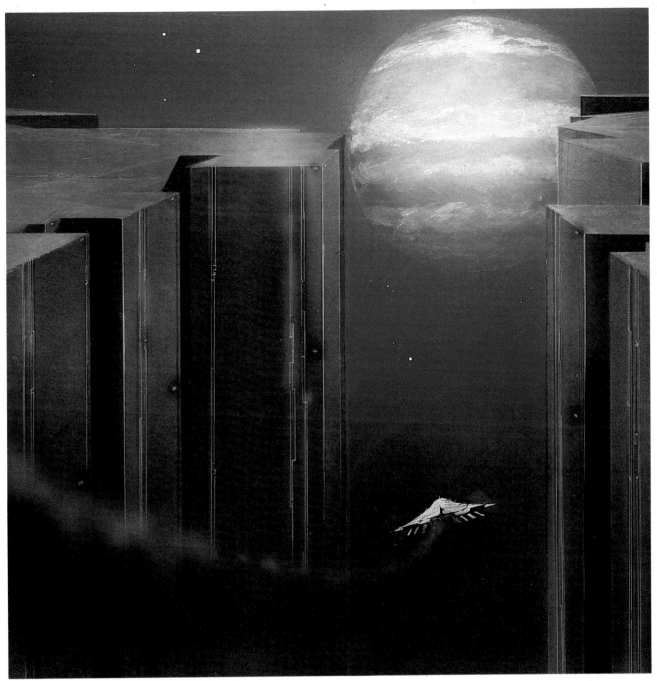

Computer 2, John Harris.

point of it all is. Unfortunately he fails to recognise the Grail as providing the answer. In fact when all his knights, led by the head-strong Gawain, vow to go in quest of the Grail he sees it only as a disaster for the Round Table. Although the point is not specifically made in Malory's book, it is likely that this failing more than anything seals Arthur's tragedy and the downfall of his Kingdom.

The trouble is that from his pinnacle of power, Arthur is slow to

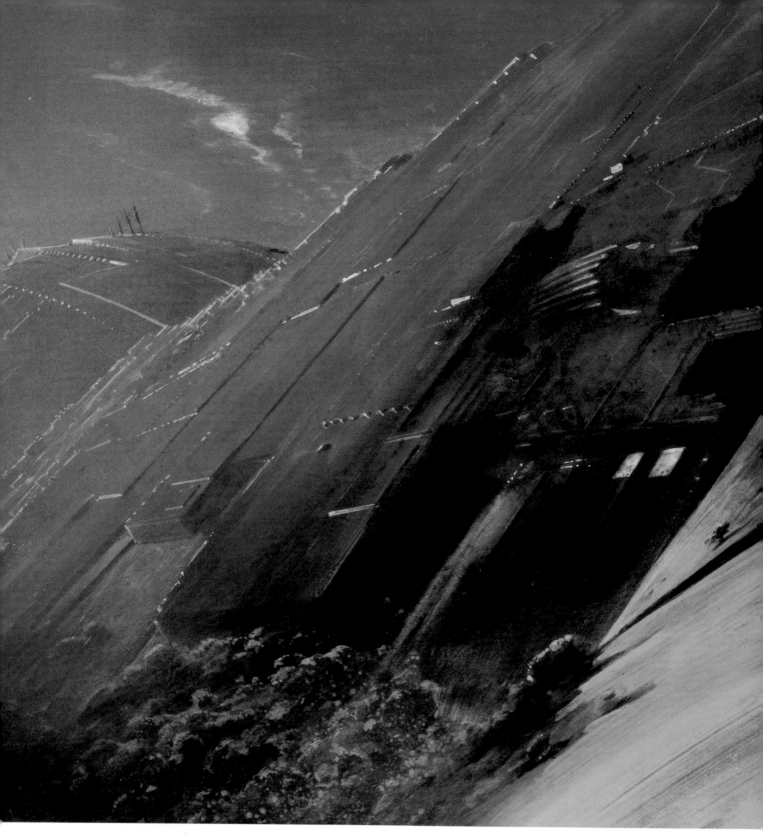

realise that its foundation is being eroded; and when he begins to suspect it he cannot easily see what is doing the damage. Having established his ordered and Chivalric Kingdom against all odds he later fails to recognise the need for change if it is to be maintained. For this he cannot really be blamed, of course, since it is the usual way with human affairs. The tragedy lies in the young, almost godlike hero being reduced in the end to such common human frailty.

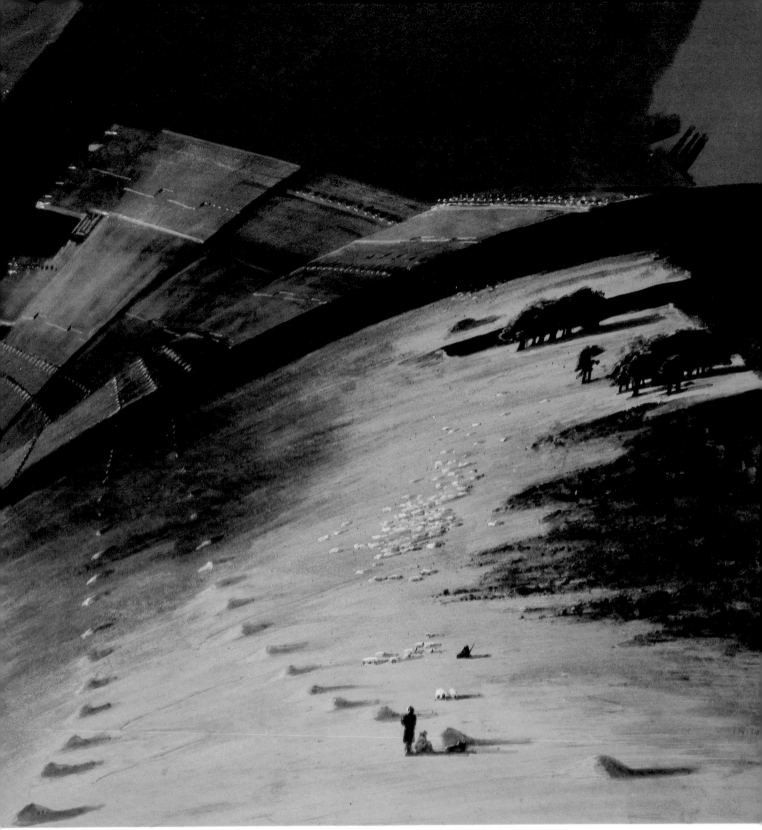

Shepherds on Wreck, John Harris.

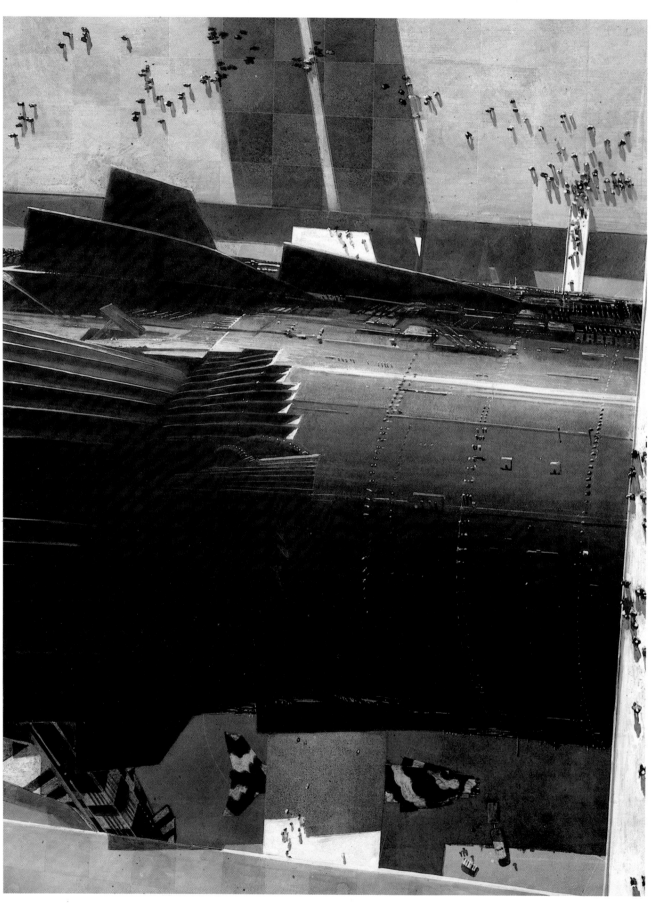

Space Station, John Harris.

THE GRAIL QUEST

Space exploration appeals to all levels of the heroic imagination. As we have seen, to some it simply offers a new field in which glorious adventures may be had and vast prizes won. To some it seems humanity's only longterm hope of survival because of both our self-destructive tendencies and the limits of the earth's resources. But some look to space to provide in one way or another the answers to the riddles of life, death, consciousness, intelligence and the ultimate purpose of it all. For these people the Grail Quest exists not in dusty old tomes telling of an imaginary age of Chivalry but up there in the shimmering night sky, and who can say they are not right?

In recent years several books have appeared telling of strange discoveries being made in both micro- and macrophysics which are changing scientists' view of the universe and even leading some to find parallels between their discoveries and the teachings of ancient scriptures like the *Bhagavad Gita*. A good example is *The Tao of Physics* by Fritjof Capra.

Having led the way out of the Middle Ages by divorcing itself from metaphysics and philosophy, it is quite possible that science will also arrive back at its starting point; though if this happens and if recent history is anything to go by it will take about a century for this to percolate through to everyday thinking, which has only recently caught up with the materialism of Victorian scientists.

Of course, in practice space travel is usually rather more prosaic than any heroic dream — as demonstrated by the astronaut who, being asked his reaction to seeing the Earth from halfway to the Moon,

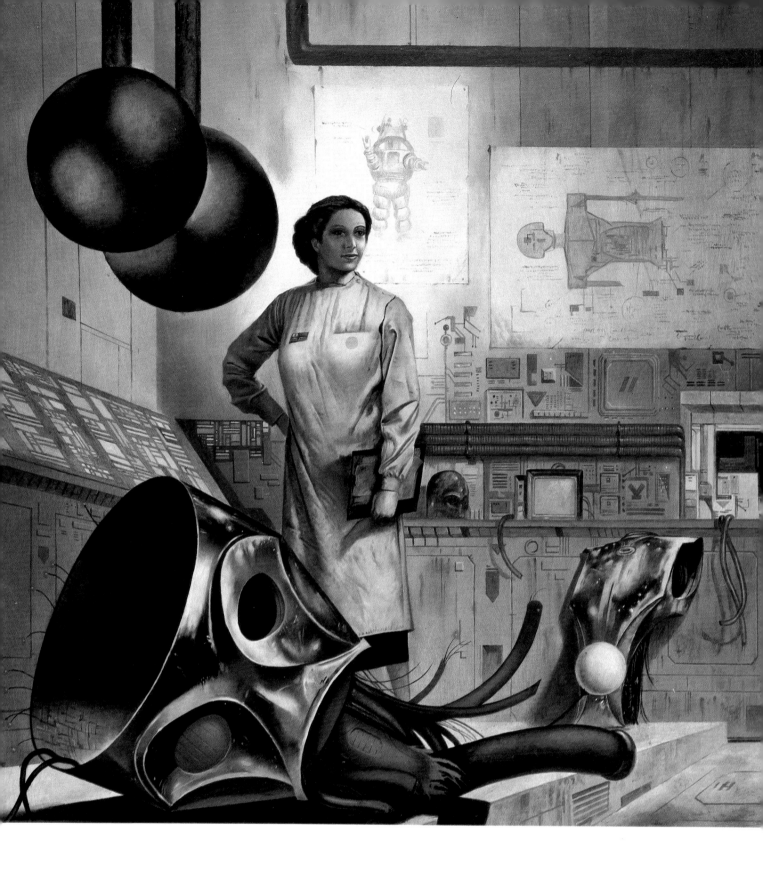

replied that all he was thinking about at the time was that each of the ten million bits holding his spacecraft together had won the cheapest tender on a government contract.

But this should not blind us to the fact that the impulse behind the

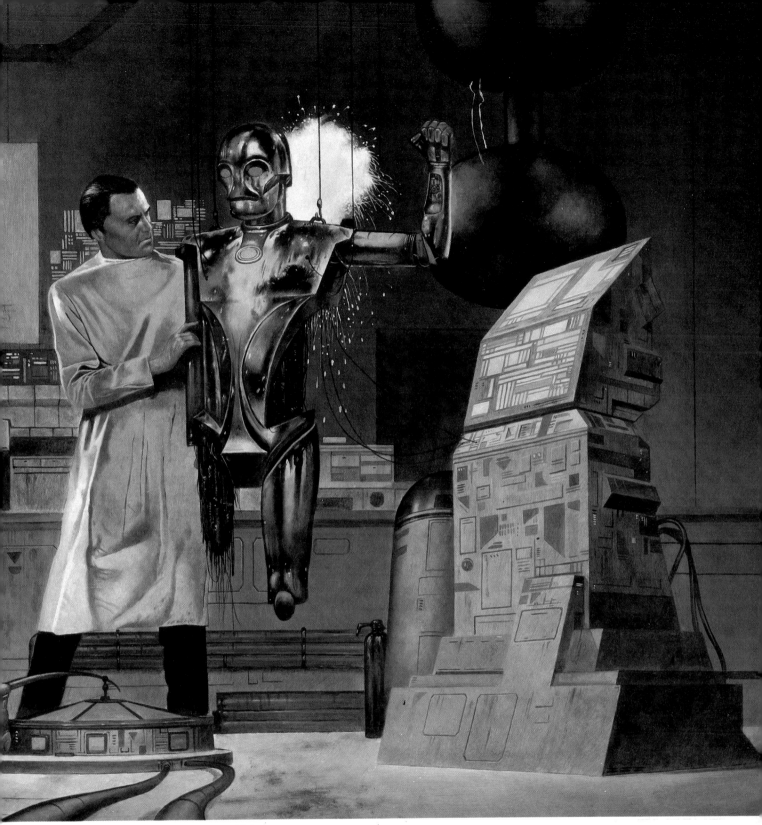

The Immortals, Les Edwards.

reality was the sum of all the heroic dreams of those collectively responsible for putting the thing up there. Reality may usually turn out to be prosaic but it begins with a dream.

Perhaps the greatest and certainly the most famous Fantasy novel to

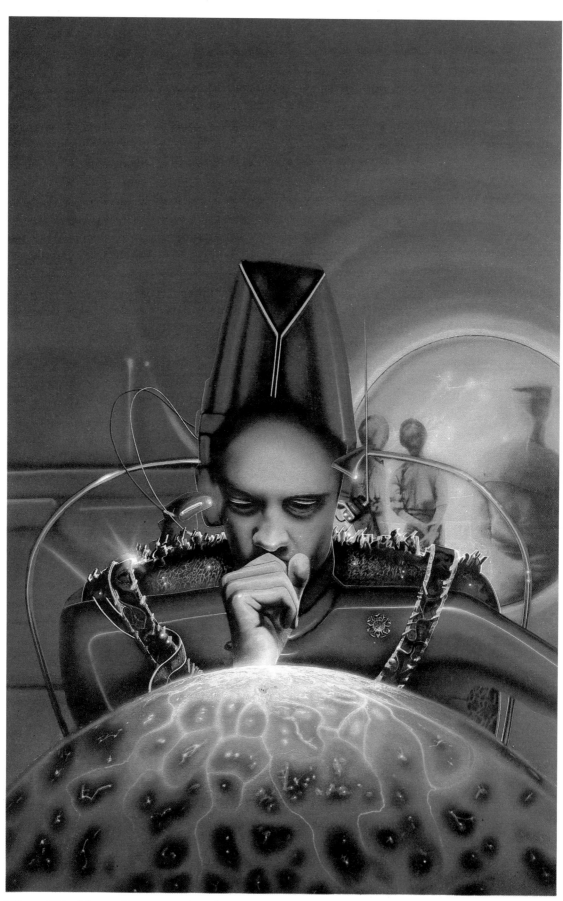

Three Worlds to Conquer, Ian Craig.

130

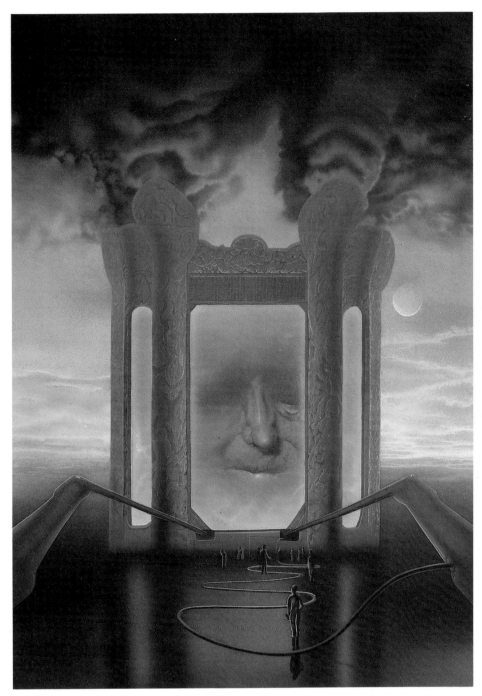

I Will Fear No Evil, Ian Craig.

emerge in Europe this century is Tolkien's *Lord of the Rings*. Its wide appeal must be due to its success in embracing many levels of the heroic dream simultaneously, but at its root lies a Mystical Quest upon the outcome of which everything else depends.

Frodo Baggins may seem an unlikely Galahad and his quest may not immediately resemble that of the Holy Grail but at heart they are the same. Frodo's task may be (like Siegfrieds's in the *Song of the*

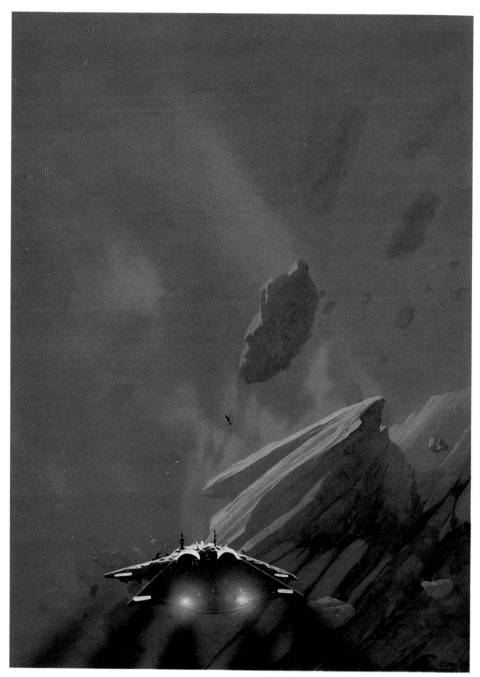

Red Chaos, Ian Craig.

Niblungs) to destroy an instrument of power rather than find one, but to achieve this demands all the virtues required of those who would achieve the Holy Grail. And as with Galahad his reward for success is not power, glory or riches but a knowledge of the emptiness of these things and a longing to leave his earthly home for the nearest equivalent of Heaven, the Elven land in the west.

Such a complete renunciation of life is not always necessary for the hero or heroine of a mystical quest, but the mystery they seek must be

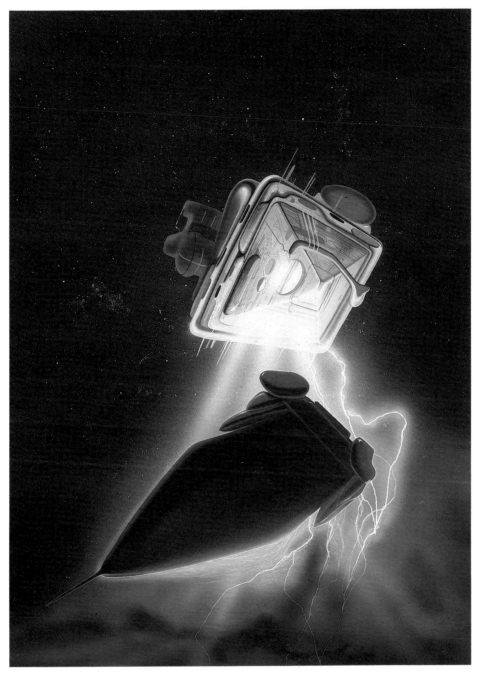

The Presence, Ian Craig.

more important than life and so worth risking it for.

In children's stories the quest often takes the form of the search for a lost parent (*i.e.* identity). For adults it is usually less simple but often, too, it is still a case of searching for a lost clue to origins as in, say, the story *2001: A Space Odyssey*, particularly in Stanley Kubrick's film version.

Past and future tend to become mingled in mystical quests because the object of the quest is something which stands outside the space-

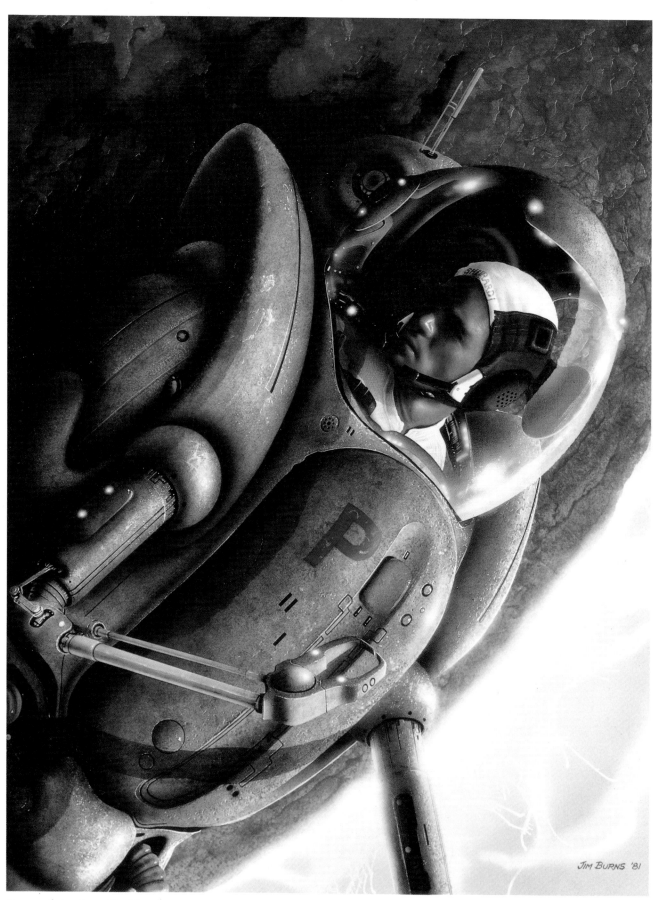

Best of Arthur C. Clark, Jim Burns.

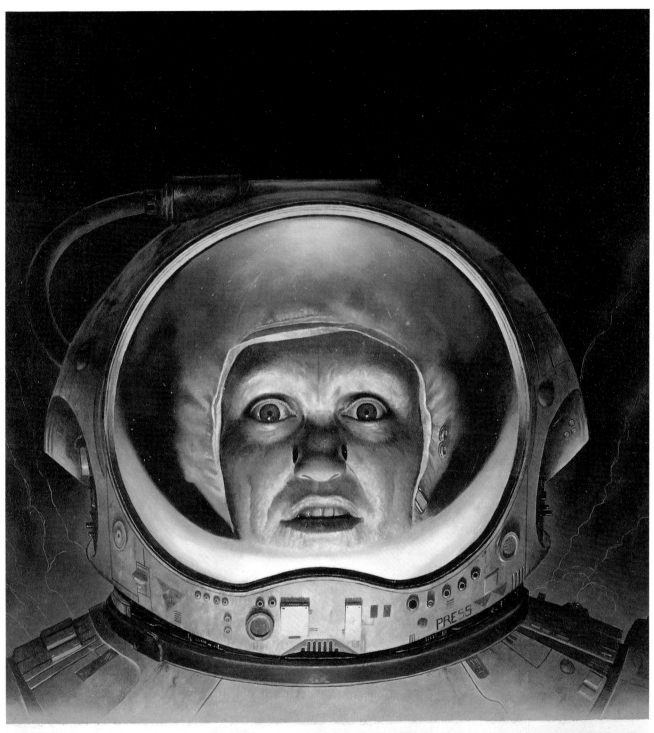

Best of Frank Herbert, Les Edwards.

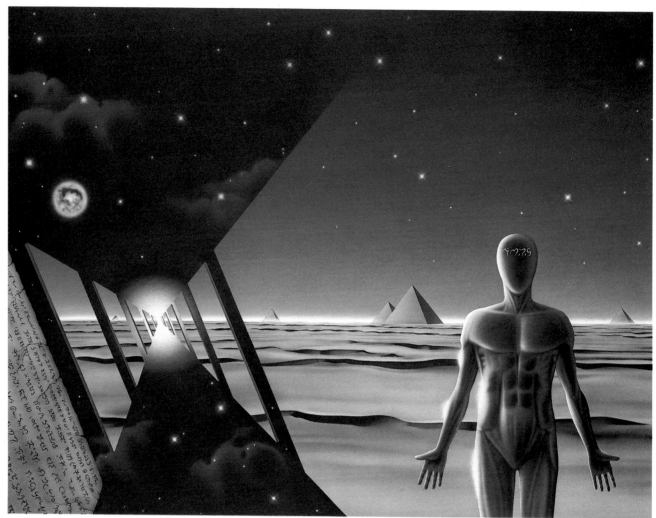

The Portals, Peter Gudynas.

time continuum. The child in searching for its parent is at the same time seeking its own future identity. The speculators who still puzzle over the mysteries of pyramids are not just hoping to learn more about the ancient Egyptians or Mayans or whoever, but are hoping either consciously or unconsciously to discover some lost wisdom which they can use, some key to another dimension.

In the Arthurian cycle Galahad is an almost Jesus-like figure, apart from a readiness to use his lance in a good cause. In keeping with Medieval Christian mores much of his reputation for virtue stems from his being a virgin.

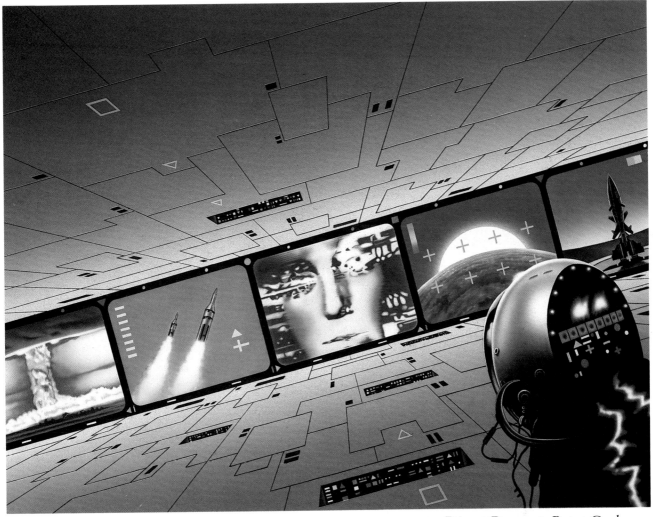

Direct Descent, Peter Gudynas.

In the earliest Grail legends there is no mention of Galahad and the hero is Perceval. Perceval is a rather problematical character, being innocent only in the sense of being simple—a holy fool, in fact. He means no-one any harm but still manages to cause a fair number of tragedies in his bumbling about the Kingdom of Logres. Also, far from being a virgin he is rather inclined towards promiscuity, which leads to more trouble.

The apparent unlikelihood of Perceval achieving the Quest over the heads of all the other Chivalrous knights stems from the presentation of the Holy Grail in purely Christian terms as the Cup of the Last

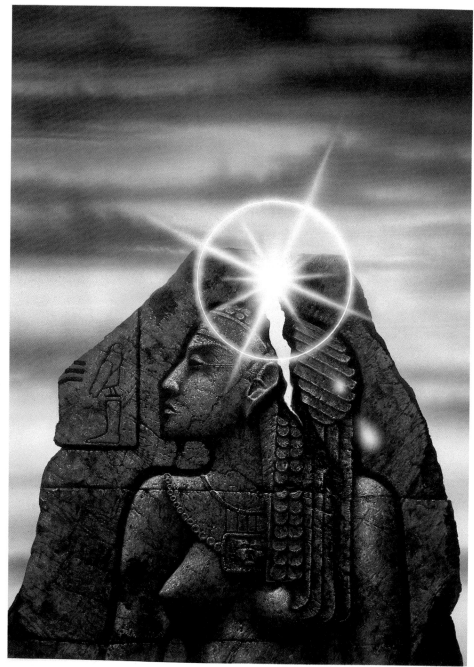

Circle of Ra, Tony Roberts.

Supper and the Crucifixion. At the kernel of the legend lies a much older pagon one in line with a Celtic tradition of sacred vessels from the Other world able to provide any food the heart desires along with mystical enlightenment. In pagan times Perceval would have seemed a far more likely candidate for the Grail since fools were often known to be favoured by the gods, but his outrageous behaviour was clearly too much for some Medieval scribes and led to the creation of Galahad. As consolation, Perceval survived in only slightly modified

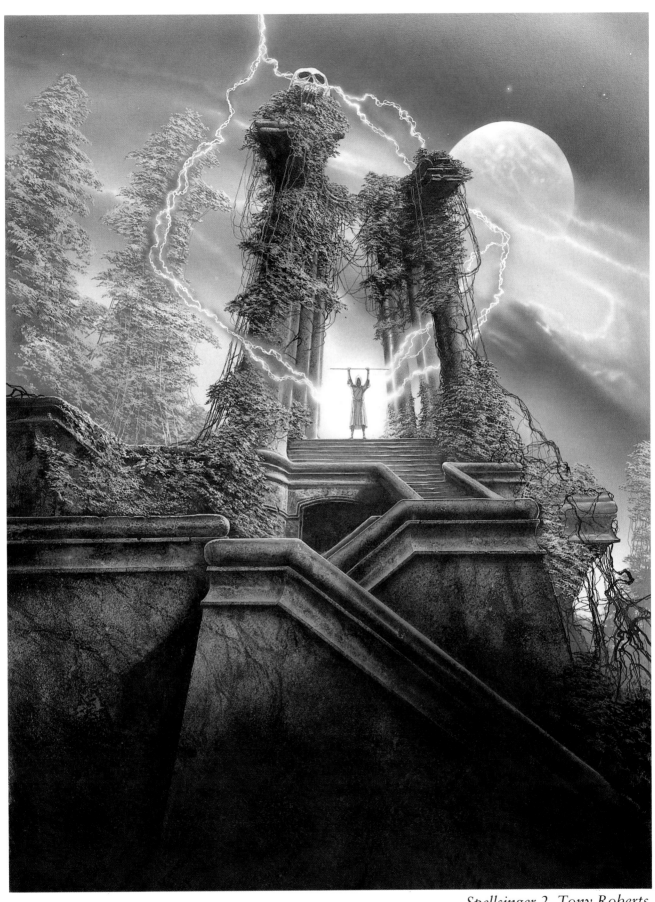

Spellsinger 2, Tony Roberts.

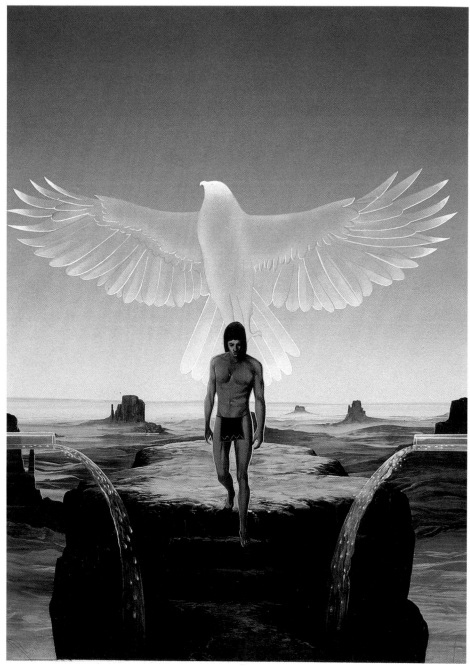

Grimes, Peter Goodfellow.

form as one of Galahad's two companions at the end of the adventure, and was granted a partial glimpse into the mystery.

As mentioned earlier, Lancelot was also displaced by Galahad within the framework of the later accounts as 'the best knight of the world', giving up the title without argument once he recognises that all his great deeds were not prompted by a pure love of Chivalry but a desire to impress the Queen. After renouncing his illicit love for her he too is granted a brief glimpse of the Grail mystery.

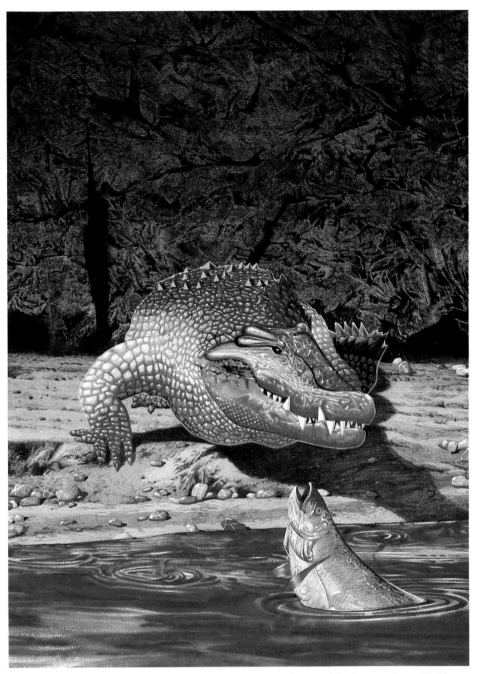

Crystal World, Peter Goodfellow.

When Galahad, Perceval and Bors eventually find and achieve the Grail they are told that Logres is no longer fit to be the home of so sacred a mystery, and they must sail away with it to the city of Sarras in or near the Holy Land. There after a short while Galahad willingly embraces death, soon to be followed by Perceval, and the Grail is lifted up into Heaven.

Bors survives to carry the tale back to Arthur's somewhat depleted court (many having died on the Quest), and it is heard with 'great joy'.

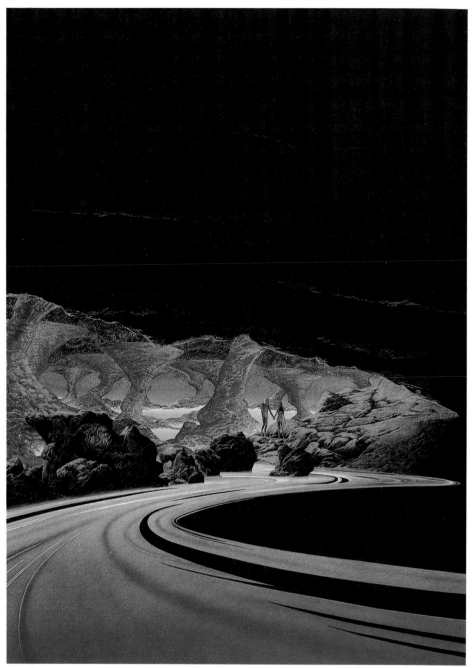

Absolute Elsewhere 10, Peter Goodfellow.

King Arthur seems to completely miss the significance of what has happened and only seems relieved at the Quest being over so that things can get back to what they were. However, the slide into ruin soon accelerates with a vengeance. Lancelot forgets his renunciation and begins open adultery with Guenevere. In the trouble that follows, he kills Gawain's beloved brother and Gawain, who has always been uneasy in his Chivalric role, now casts it aside and wants nothing but revenge. Gawain's blind hatred in fact becomes the instrument of

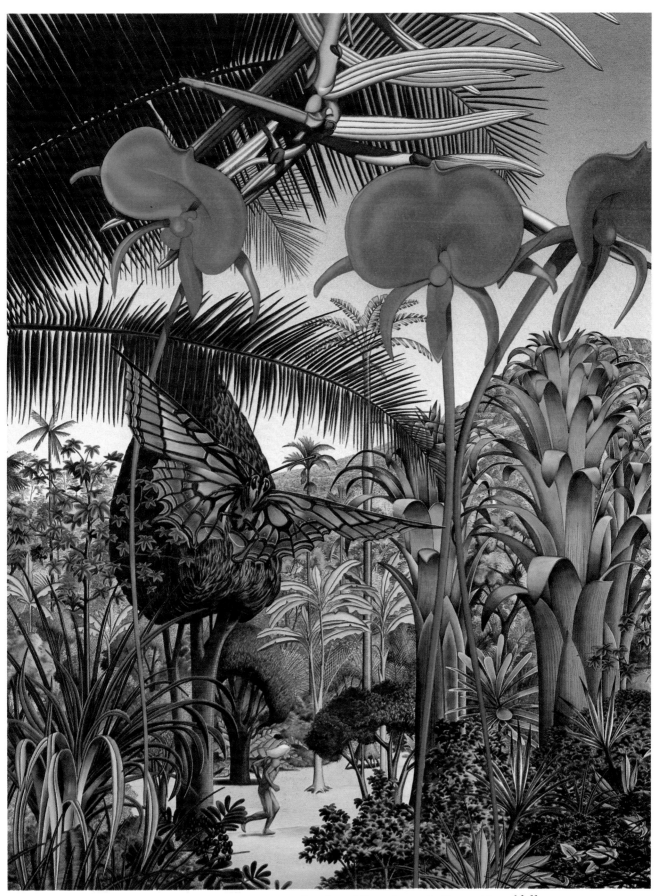

Absolute Elsewhere 4, Peter Goodfellow.

143

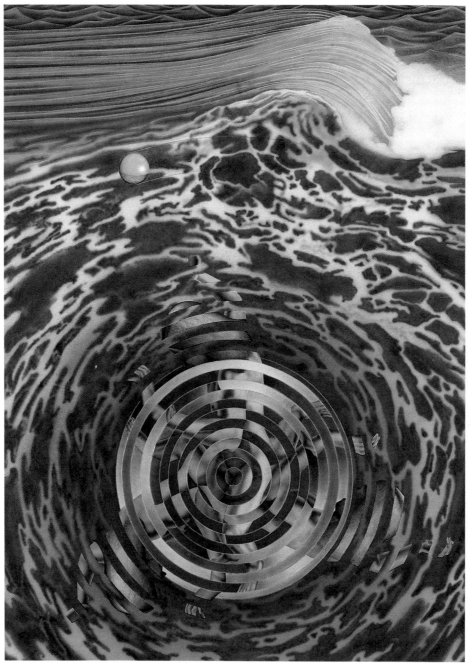

Absolute Elsewhere 8, Peter Goodfellow.

Arthur's undoing because the war against Lancelot opens the way
for Mordred (Arthur's incestuously conceived son by Morgan le Fay)
to seize power and provoke the final battle in which Arthur dies and
the Kingdom of Logres comes to an end.

The reason the legend of the Holy Grail can still exert a fascination
on the modern, and often post-Christian, European mind is that it
hints at something which is not confined to Christian teachings.
In Medieval times, with the prevailing almost hysterical reverence for

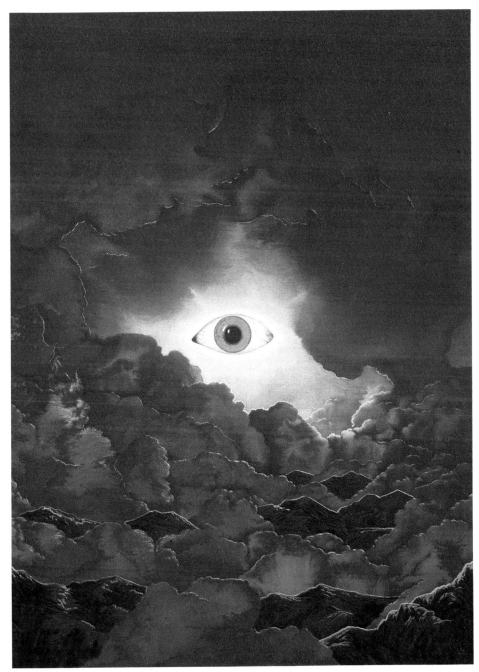

Lord of Light, Peter Goodfellow.

saintly relics, it was enough simply to describe the Grail as being the most precious relic of all for the meaning to be conveyed. Just as in Malory dangerous foreigners are often described as Saracens whereas in the time of the original Arthur they would most likely have been Saxons.

The Grail itself is a Platonic idea not to be identified too closely with the form it appears to take at any one time. In the pre-Christian age in which the legend originated it must have been conceived in very

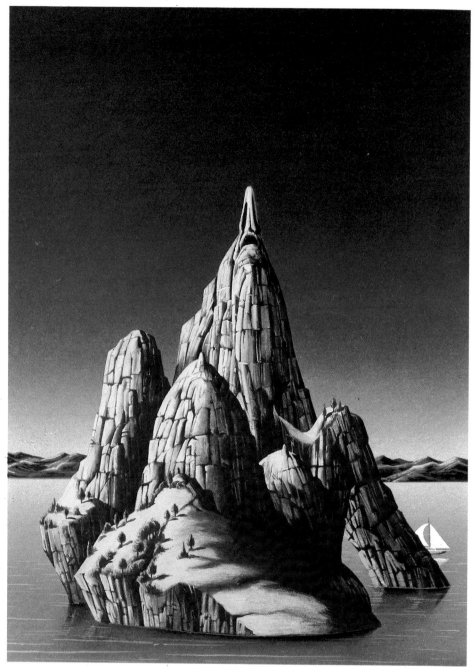

Moreau's Other Island, Peter Goodfellow.

different terms, yet the mystery conjured in the minds of an audience would have been much the same.

The Grail is the mystical experience that makes sense of all things. It is distinct from the Fountain of Eternal Youth or the Well at the World's End, which promise all the joys of this world without their attendant pangs. It is that which opens mortal eyes to the Infinite, the portal to Heaven or Nirvana or Enlightenment or any of the many other names it has been given at different times around the world. It is

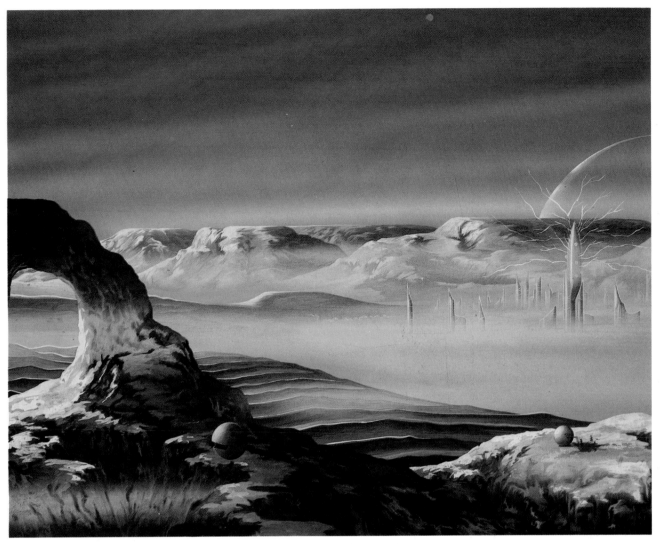

Terminus, Peter Goodfellow.

the glimmering light of promise, the heroic dream that draws a certain kind of individual down any of a thousand different paths, down electron microscopes or radio telescopes or whatever, seeking nothing more concrete than an understanding of their place in the universe.

As such, the story of the Holy Grail has far from exhausted its significance for the descendants of its original Medieval audience since in many ways our position is not so very different to Arthur's, in the fields of both politics and technology and possibly others as well.

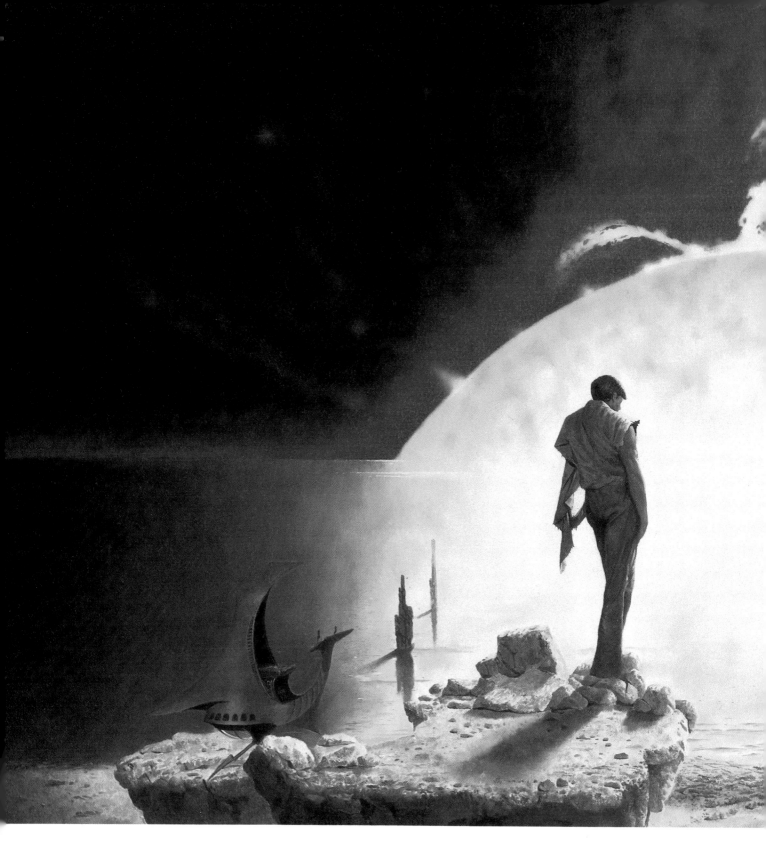

Technology has advanced in this century beyond the wildest dreams of the engineers in the last, but it would be a rash person who claims that it has improved the human condition to the same degree. The problem is that technology is in itself amoral. It is merely a tool whose usefulness depends on how it is applied. Many people see technology

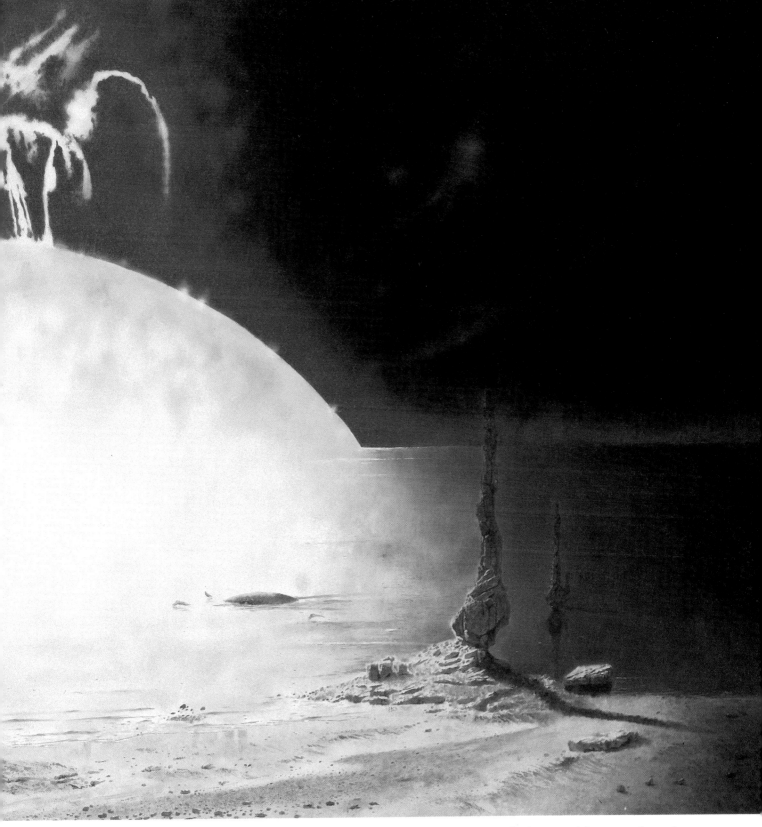

The Time Machine at The End of The World, Les Edwards.

as a runaway train galloping towards some disaster (Science Fiction writers not being the least of these) but the real question is why does the vast might of technology end up being applied to so many ultimately sterile ends?

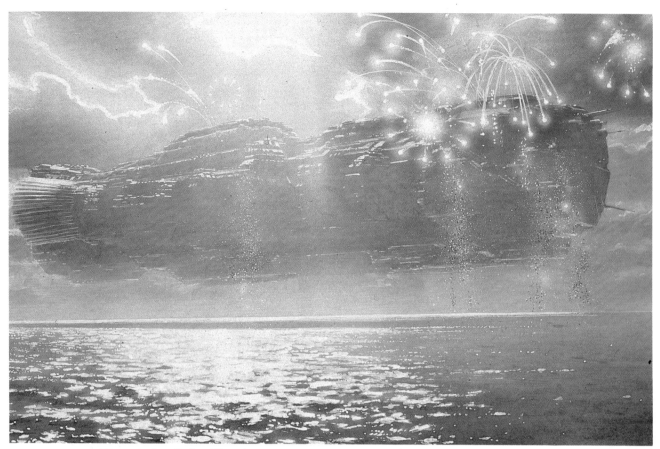

Fireworks, John Harris.

There seems a yawning gap between humanity's understanding and control of the laws of matter, and understanding and control of itself. For an example one has only to find the trashiest possible programme on television and consider the astonishing complexity of the process by which it appears on the screen.

Technology may have achieved wonders but it has far from banished the fundamental human fears. From the ashes of the age old fear of the imminent destruction of the world by God has arisen the fresh spectre of Mankind's self-destruction. In the developed world disease has been largely banished to the far corners of the biblical three score and ten but not everybody wants to get there.

The Holy Grail waits, glimmering at the heart of a maze, for some persistent hero or heroine to find it and then point the way to the next stage of the human race. What that direction is likely to be is anybody's guess until it becomes apparent, but there is one certainty about the future—it is never what most people at any one time imagine.

<p style="text-align:center">END</p>

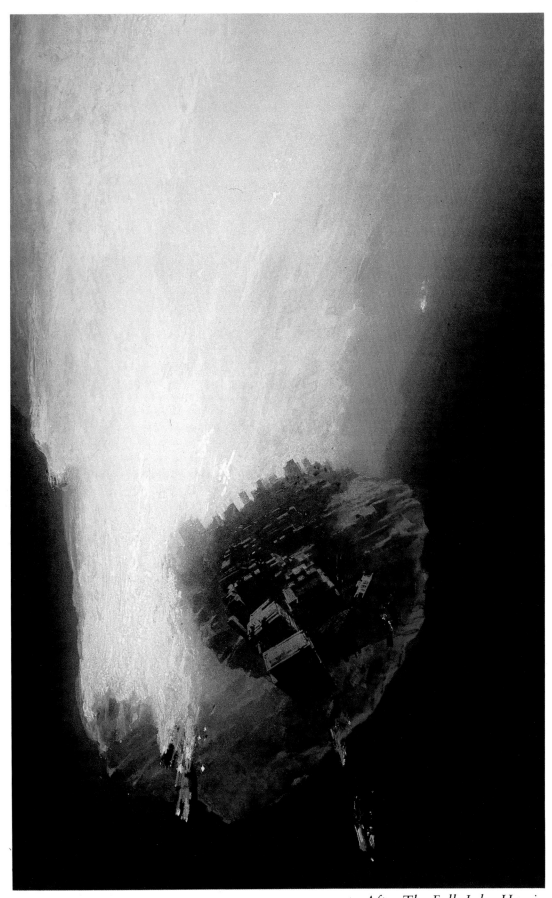

After The Fall, John Harris.

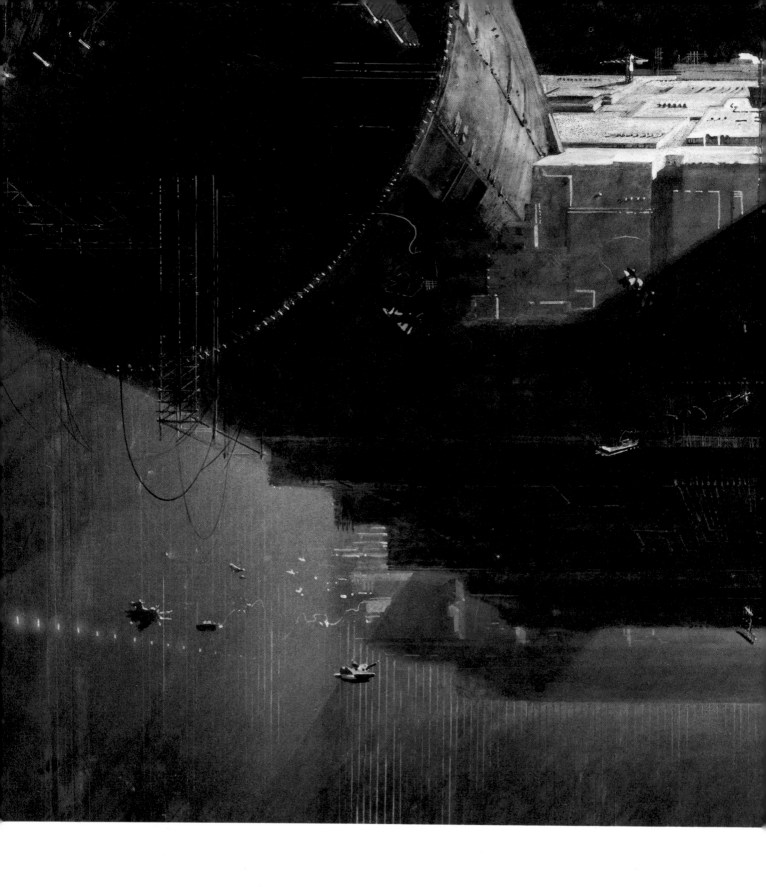

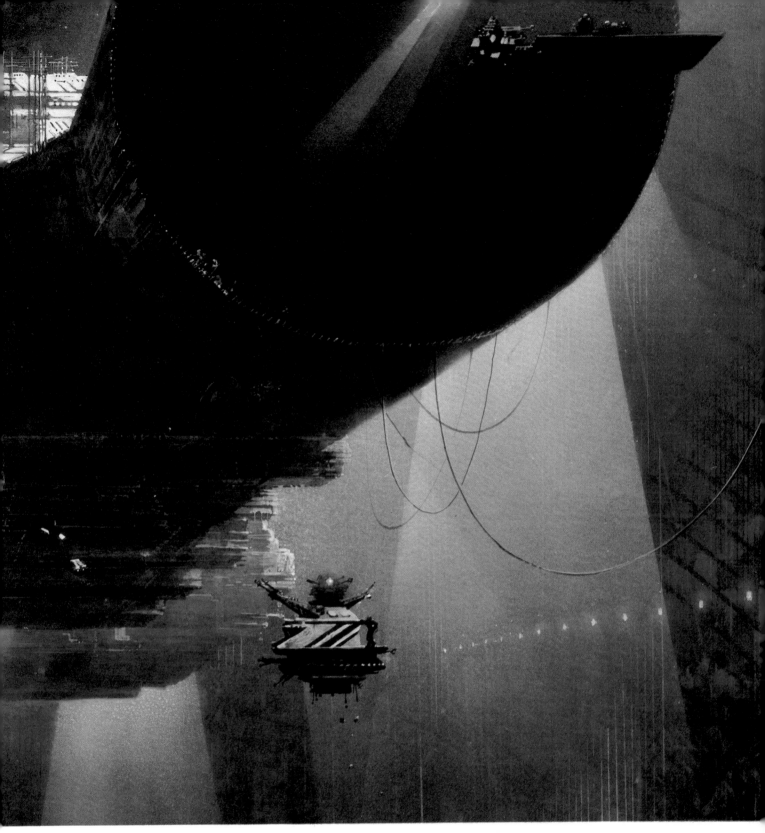

Construction of a Spaceship, John Harris.

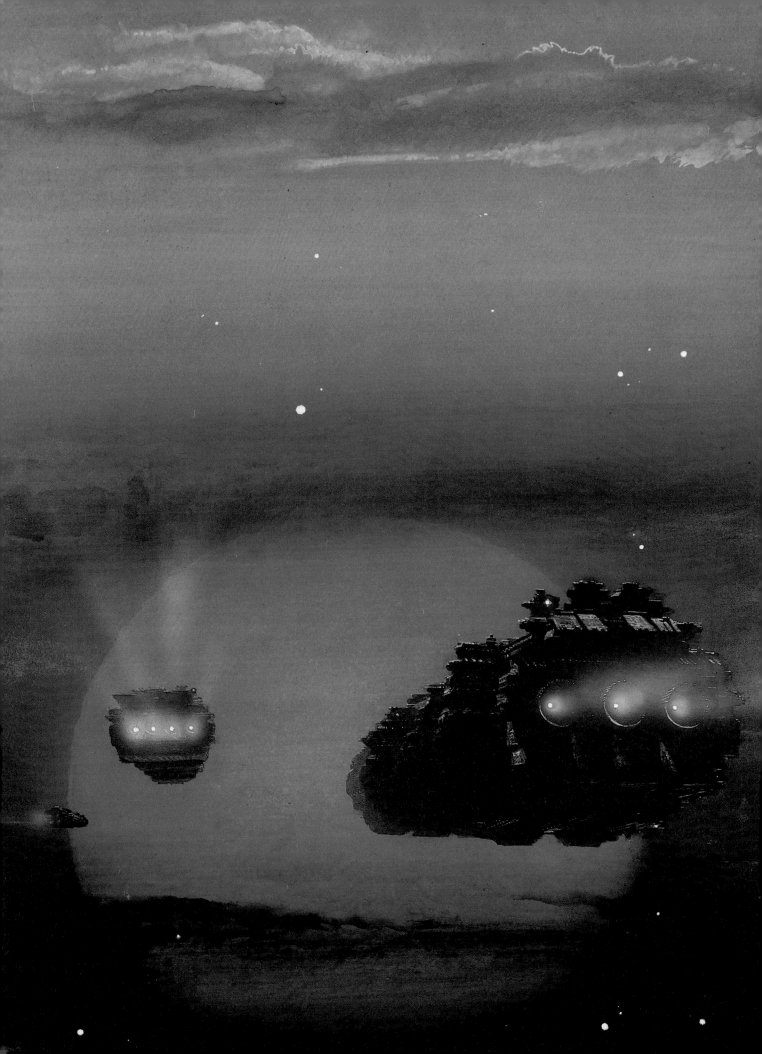

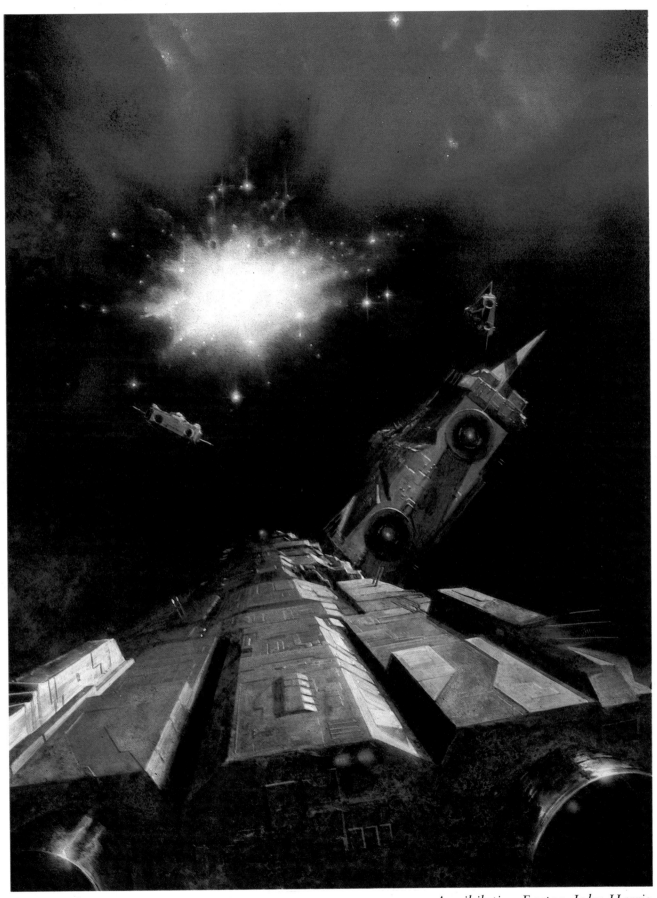

Jem 2, John Harris.

Annihilation Factor, John Harris.
PP 156/157
Crystal Henge, John Harris.

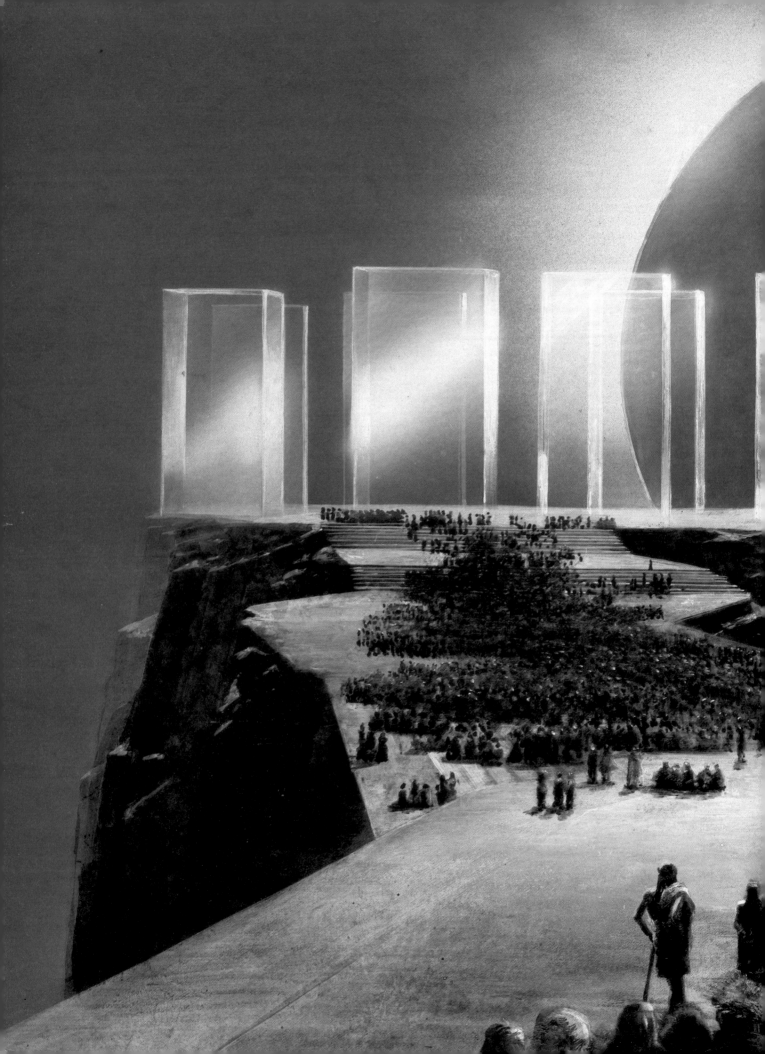

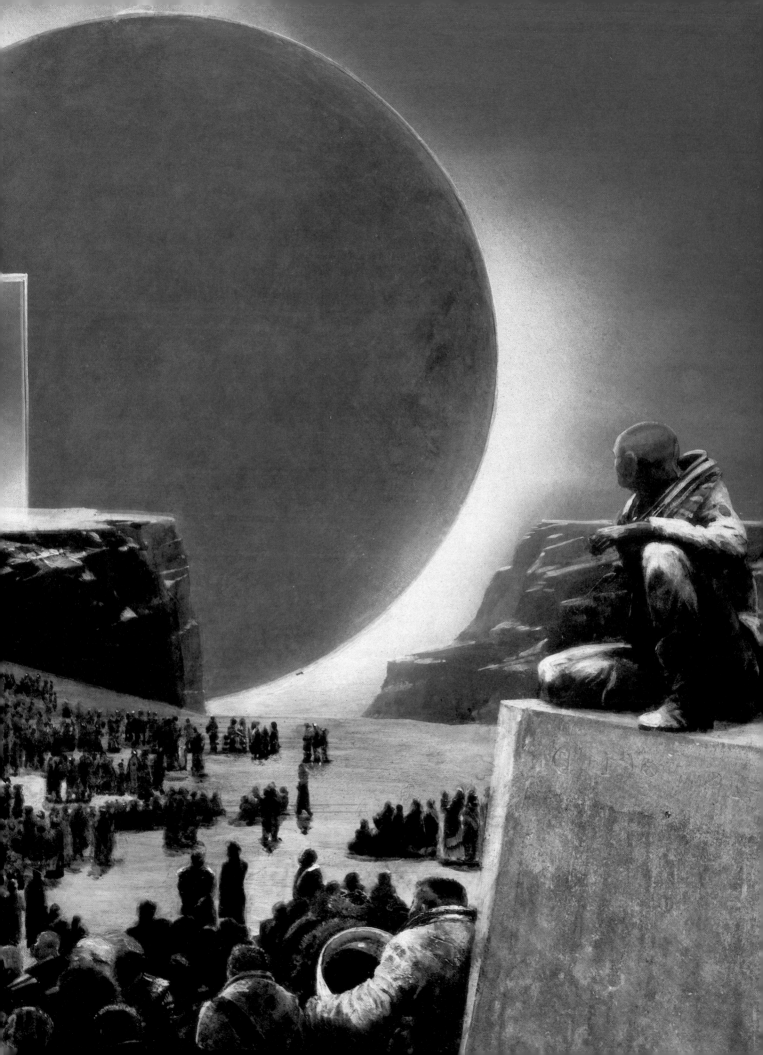

THE
ARTISTS